IMAGES
of America

JEFFERSON
COUNTY

IMAGES
of America

JEFFERSON COUNTY

Jefferson County Historical Society

ARCADIA
PUBLISHING

Published by Arcadia Publishing
Charleston SC, Chicago IL, Portsmouth NH, San Francisco CA

Printed in the United States of America

Library of Congress Catalog Card Number: 2006926128

For all general information contact Arcadia Publishing at:
Telephone 843-853-2070
Fax 843-853-0044
E-mail sales@arcadiapublishing.com
For customer service and orders:
Toll-Free 1-888-313-2665

Visit us on the Internet at www.arcadiapublishing.com

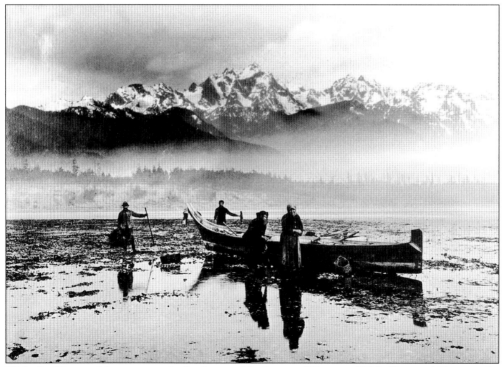

With the Olympic Mountains in the background, La-ka-nim ("Prince of Wales"), son of Chetzemoka ("Duke of York") with the shovel, is digging for clams at Scow Bay. The others are unidentified. The Prince of Wales and his wife settled on the S'Klallam's traditional grounds at the northeast corner of Indian Island.

CONTENTS

ACKNOWLEDGMENTS

The Jefferson County Historical Society collects and preserves over 20,000 historic photographs. We sincerely thank all who have donated to this collection and encourage everyone with photographs that illustrate Jefferson County's history to add their images to this resource. We thank the *Peninsula Daily News* for a grant in 2004 that made it possible for us to begin digitizing the collection. We appreciate the grant from the Institute of Museum and Library Services that made it possible for us to rehouse our glass-plate negatives.

We are fortunate to have a large cadre of volunteers who helped with this project. Margaret Lee did an enormous amount of research. Marge Samuelson, our archivist, provided a wealth of knowledge about Jefferson County history. Harleen Hamilton helped Marge find out anything she didn't already know. Vicki Davis figured out how to scan the photographs and taught and supervised those who helped her. Rosemary Melia, from Bennington College in Vermont, joined us as an archivist's intern just in time to research and write most of the captions. Jim Christenson keeps the computers updated and in working order. JCHS museum coordinator Marsha Moratti spent hundreds of hours reformatting, cropping, organizing, and finalizing every photograph and caption. JCHS director William Tennent assisted with proofing, editing, and text. For more information about the Jefferson County Historical Society, visit www.jchsmuseum.org.

INTRODUCTION

Traditionally the Chimacum, Hoh, S'Klallam, Quinault, Snohomish, and Twana tribes occupied what would eventually become Jefferson County. By the late 1700s, their people had been devastated by contact with European diseases, and in 1855, the Point No Point Treaty and the Quinault River Treaty ceded their lands and water to the United States. Today only the Hoh occupy a reservation in Jefferson County, on a spectacular stretch of Pacific Ocean coast.

European and American immigrants began to settle Jefferson County in the mid-19th century, situating in villages at easily accessible, deepwater bays. While a few adventurous families chose property inland for homesteading and farming, most activity was concentrated along the coastline, where seafood was abundant and boats of all sizes transported people and goods. Incredible forests attracted the earliest settlers. Timber quickly became the major product, mostly exported, and provided a seemingly inexhaustible resource on which to base the local economy.

The abundance of timber gave birth to many waterside pioneer settlements that began as logging sites and mill towns. Some mill towns attracted sizable populations and provided all amenities, while others became centers of shipbuilding. Port Ludlow became a mill town because the trees—which grew right to the water's edge—were easy to cut and float to the mill. Port Hadlock was a mill town born in 1870. Its docks accommodated seven ships at a time. The Puget Sound Iron Company in Irondale began producing pig iron in 1879 and was the only iron smelter in the state at the time. Farms in the Chimacum Valley, the most productive agricultural land in the county, provisioned ships resupplying at the docks in Port Townsend. The town of Quilcene, at the mouth of the Quilcene River, had hopes of becoming a rail and mining center, but its economy has remained one of logging and farming. Brinnon was settled in 1859 and has been logging centered, but many are now drawn to its scenic location on the Hood Canal to retire. Nordland was founded in 1892 by Peter Nordby and remains the only town on Marrowstone Island.

Status came quickly to the rapidly growing village of Port Townsend, located at the tip of the Quimper Peninsula at the entrance to Puget Sound. When Jefferson County was established in 1852, Port Townsend was named the county seat. In 1854, Port Townsend was chosen as the official port of entry for the Washington Territory and site of the federal custom house. Every vessel entering Puget Sound from any foreign port had to make its first stop for inspection and payment of duty on imported goods in Port Townsend. Trade ships arrived daily from all over the world. They unloaded and reloaded passengers and goods and were in the market for new crews, refitting, resupplying, and recreation. By 1890, little Port Townsend sported dozens of saloons, hotels, and rooming houses with various levels of "repute."

Investors and speculators promoted a railroad with Port Townsend as its northern terminus. Much building was based on expectations that Port Townsend would become the "Key City" of Puget Sound. However a nationwide depression hit in 1893, and fortunes were lost when over a quarter of the national railroads went bankrupt. The anticipated railroad terminus was sited at Tacoma, not Port Townsend. Concurrently increasingly dominant steamships could cruise right past Port Townsend into the calmer waters of Puget Sound and the vital port of entry status was

eventually lost to Seattle. Without the railroad to spur economic growth, the town shrank and investors looked elsewhere to make a good return. Many people left the area and some of the small towns essentially disappeared.

No other major industry arrived to replace lost maritime businesses. For the first half of the 20th century, Port Townsend depended on the military at Fort Worden and the paper mill, built in the 1920s, for its survival.

Because of its rapid economic decline, most of Port Townsend's grand Victorian buildings and homes were never torn down and built over. Many remained uninhabited until the 1970s, when cheap real estate and splendid scenery were discovered by people seeking to drop out of "mainstream" America, artists and writers seeking a creative atmosphere, and retirees fleeing urban stress. They joined the paper mill workers and increasingly unemployed loggers and fishermen in an unlikely fusion. Since then, small-business owners, persons of independent means, telecommuters, and tourists have added to the mix, making for a lively, often contentious, but never boring political and cultural scene.

One

IN THE BEGINNING

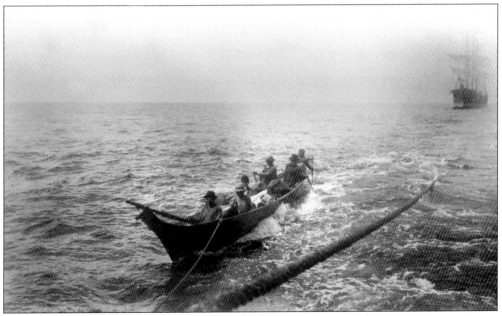

An American Indian canoe hitches a ride with a sailing ship, year unknown.

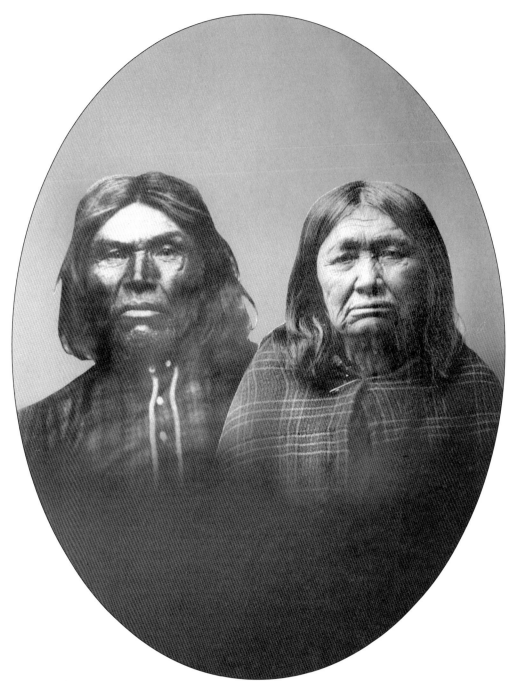

Chetzemoka (*c.* 1808–1888) was chief of the S'Klallam tribe, one of the many peoples indigenous to what would become Jefferson County. Nicknamed the "Duke of York" by settlers, Chetzemoka befriended James G. Swan during his trip to San Francisco in the early 1850s. On January 26, 1855, Chetzemoka led 56 representatives from the S'Klallam, Skokomish, Chimacum, and Twana tribes in signing the Point No Point Treaty with territorial governor Isaac Stevens, agreeing to give up ancestral lands in exchange for $60,000, to be paid in small increments over many years. He is pictured here in Anglo-American clothing with one of his two wives, "Queen Victoria."

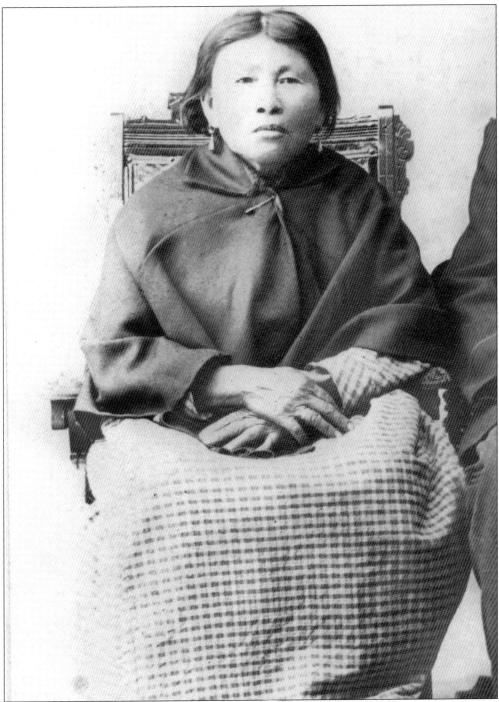

Sally Wilson Bishop (Lag-wah), the daughter of Snohomish sub-chief S'hootst-hoot, married prominent Chimacum settler William Bishop Sr. in 1858. After seven years, two sons, and a daughter, William and Sally divorced in 1865. Their youngest son, William Bishop Jr., became a Washington state senator, and his daughter, Kathleen Bishop, was a Snohomish tribal judge and an advocate for small tribe causes.

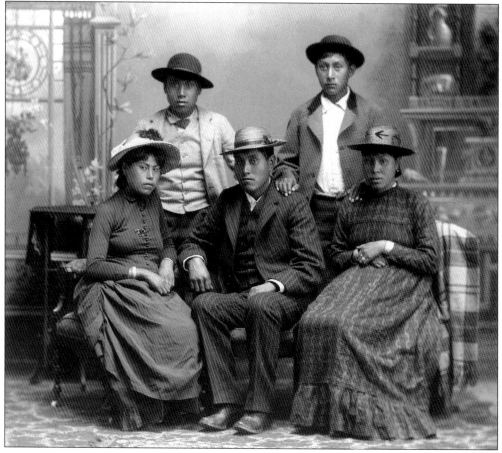

Johnnie Bye (center) and four others, identified only as Native Americans, are pictured enjoying early 20th-century opulence unknown to many of their people.

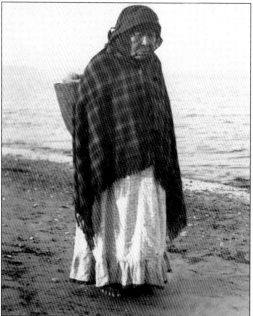

"Old Sally" walks barefoot along the coast of Point Hudson, possibly on a clam-digging excursion.

Two

FROM FAR AWAY

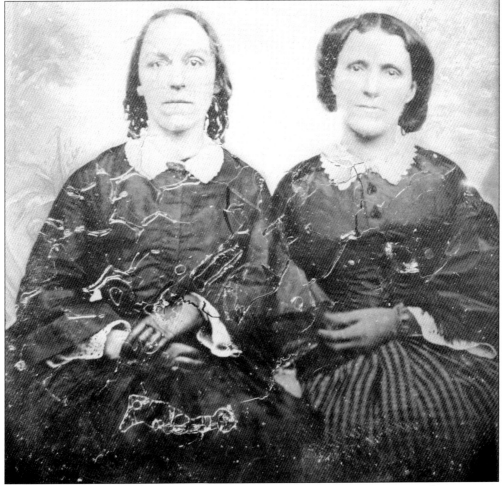

Lucinda Bingham Hastings and Sophia Pettygrove are said to have been the first non-Indian women to set foot in the Port Townsend area. Both raised large families and lived the dichotomously rugged and opulent lives of wealthy pioneers.

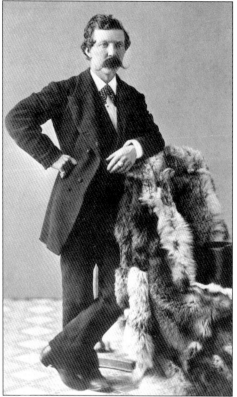

Oregon Hastings, born April 26, 1846, eldest son of city founder Loren B. Hastings, became involved in his father's mercantile business and bought Joseph Kuhn's photography studio in 1870. He died in Victoria, British Columbia, in August 1912.

Lucy Pettygrove, daughter of Portland and Port Townsend cofounder Francis W. Pettygrove, married merchant Capt. Thomas J. Connor in 1876.

Emma Littlefield Hastings was born in Maine in 1860 and married Loren Bingham Hastings in 1878. She died in Port Townsend in December 1910 of heart failure, the result of a lifelong heart defect.

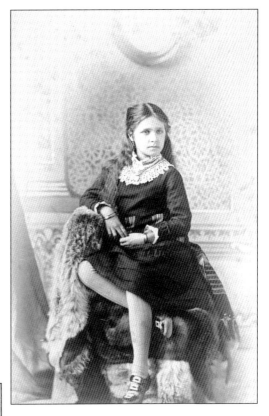

Samuel Hadlock (1829–1873), a New Hampshire native, founded the town of Port Hadlock in 1870 after nearly 20 years of restless job-hopping throughout the Northwest. He also headed construction of Hadlock's sawmill.

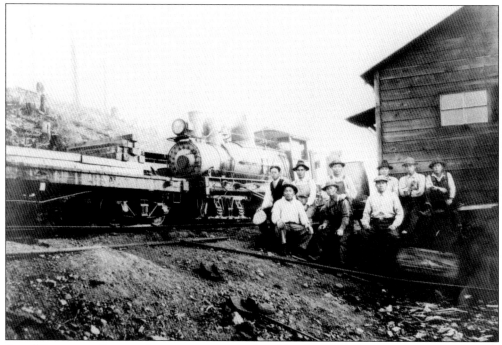

An all-Japanese railway maintenance crew, employed by the Webb Logging Company, poses at their workplace along the Duckabush River in 1925. Kaichi Kawamoto, the crew's foreman and a resident of Quilcene, sits second from the right in the front row.

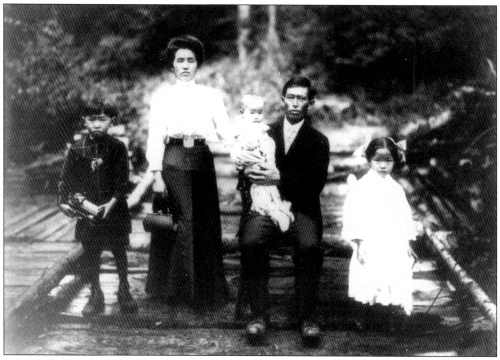

In 1913, the Kawamoto family sits for a portrait on the Andrew Matson farm in Quilcene. Pictured, from left to right, are Joseph, Itsuno, Pauline (Yukiye), Kaichi, and Jeanette (Yoneko).

Cyrus F. Clapp, born in Maine in 1851, arrived in Port Townsend in 1869 to work in the Cosmopolitan Hotel owned by his uncle. Here he wears his clerk's uniform in 1872. Clapp later became a successful businessman, buying the hotel in 1875 and establishing a bank behind the cast-iron facade of the Clapp Building in 1887.

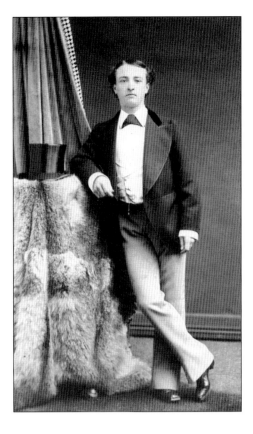

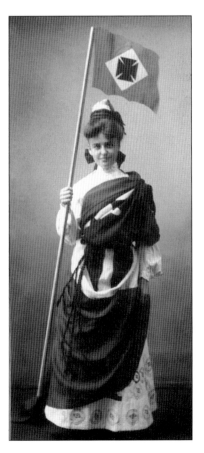

Hilda Eisenbeis (1890–1974) was the daughter of Charles Eisenbeis, a very prominent early entrepreneur and Port Townsend's first mayor. She attended the University of Washington, where she joined the Gamma Phi Beta sorority. She never married and was described in her obituary as a "sports enthusiast."

This unidentified Port Townsend fire chief may have dealt with the devastating uptown fire on June 17, 1900, which destroyed or damaged seven businesses.

A jauntily dressed young man, identified as James Smith, was perhaps caught up in the railroad speculation fervor of the 1890s.

Fred Howard Plummer, a son of Alfred A. Plummer Jr., wore dresses in his early childhood, as was the custom for young boys at the time.

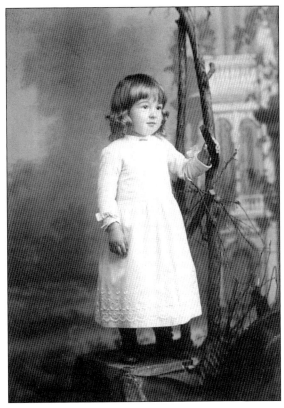

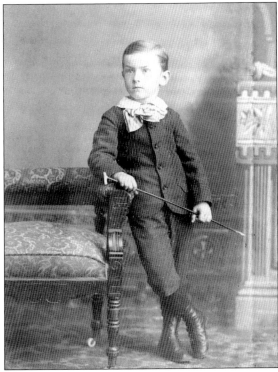

Elmer Plummer, born February 4, 1886, in Port Townsend, was the son of Kate Davis Hill and Alfred A. Plummer.

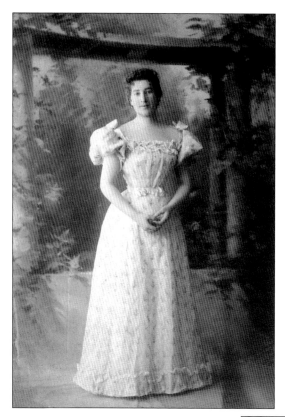

Adele Maas was born in Germany in 1869. In 1887, her family forced her to enter into an arranged marriage with German-born Port Townsend businessman Israel Katz. After years of an unappealingly rugged pioneer life and the deaths of two of her four children, Adele Katz divorced her husband and moved with her lover Herbert Millar to San Francisco, where she opened a beauty salon. The salon was a hit, but when her new husband swindled her out of the business and left her for a younger employee, Mrs. Millar suffered a nervous breakdown and spent the rest of her life in relative poverty until her death in the 1930s.

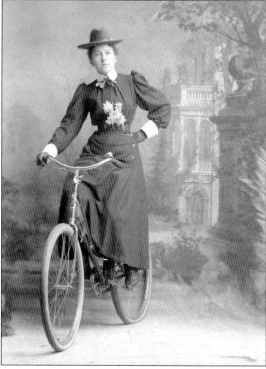

Mamie Meyerhoffer Maas poses astride a bicycle. She was a private tutor to Israel Katz's children and later married their uncle, local dentist Dr. Louis H. Maas.

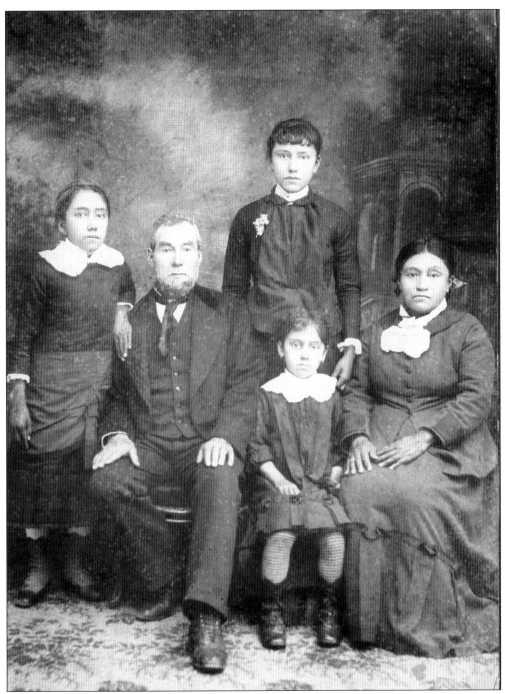

James Keymes, a mariner who had a brief stint as Port Townsend postmaster in the 1860s, settled at Adelma Beach in 1851 and fought in the Indian Wars of 1855–1856. Interestingly he later married Elizabeth Hall, an American Indian woman, and had three daughters. Pictured here, from left to right, they are Mary, Elizabeth, and Sadie.

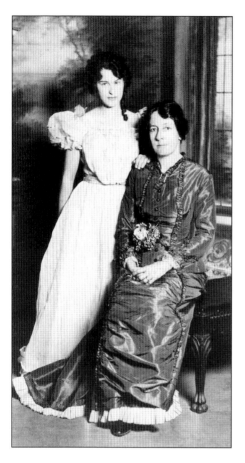

The recently widowed Mrs. Mamie M. Maas and daughter Johannette Maas sit for a photographer in 1923, within a year of Dr. Louis Maas's accidental death by gunshot.

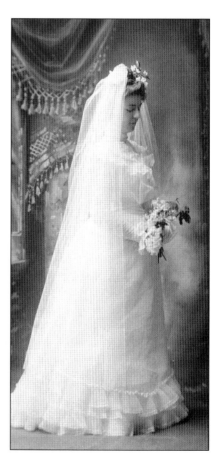

Minnie Short, dressed in this delicate wedding gown, married surveyor J. C. Phillips in 1901. Phillips was the chief engineer at Fort Flagler.

Two unidentified dandies prepare to step out for a night on Water Street in the 1900s.

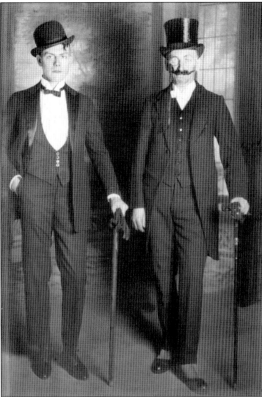

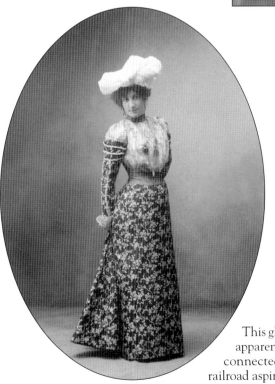

This glamorous lady, identified only as "Kitty," was apparently the daughter of a wealthy railroad man connected with Port Townsend's ultimately failed railroad aspirations in the 1890s.

Gertrude Willison (1873–1967), whose father was a prominent medical doctor and state politician, is pictured here at age five. She went on to attend school in Connecticut and became an acclaimed portrait painter.

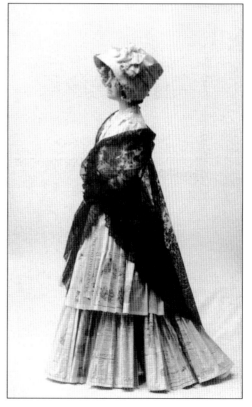

Nell Frances Willison (1882–1965) sports a *Port Townsend Leader* costume for a parade. The daughter of Dr. H. C. Willison, she studied violin in Europe before returning to the United States to teach in New York and Olympia.

James G. Swan (1818–1900), pictured here as grand ruler of the local Elks in 1898, was an early Port Townsend resident remembered for his newspaper articles and books on his experiences with Chetzemoka and other native people, as well as his anthropological contributions to the Smithsonian. He left his wife and children behind in Boston when he began his life out west in 1849.

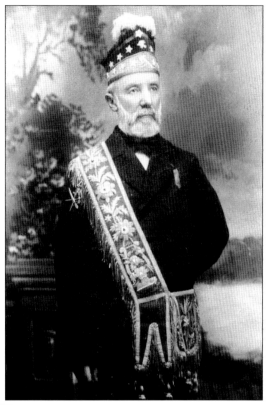

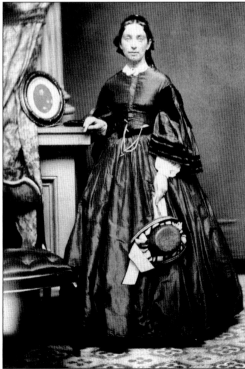

An unidentified Port Townsend woman sports the latest finery, c. 1864.

Florence Lake (b. 1903) was the only daughter of Sanford T. Lake, manager of the Port Townsend Dry Goods Company. She married C. R. Wallis of La Mesa, California.

Mary Ann Bishop (1851–1924), the daughter of Thomas Bishop and Emily Bellinghurst, married Chimacum pioneer William Eldridge in 1870, though Eldridge was over twice her age.

Emma Ray Libby, pictured here in 1885, was the daughter of successful steamboat captain and stevedore Capt. John B. Libby.

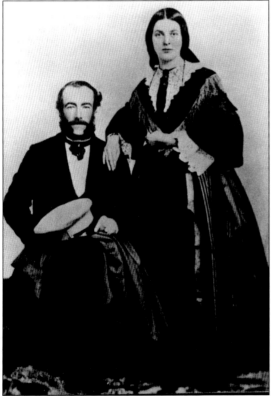

George and Emma Eliza Batting Barthrop, pictured here at their wedding, lived above Mr. Barthrop's Water Street paint and wallpaper business in the 1860s. Mrs. Barthrop ran the news depot across the street. The couple had seven children.

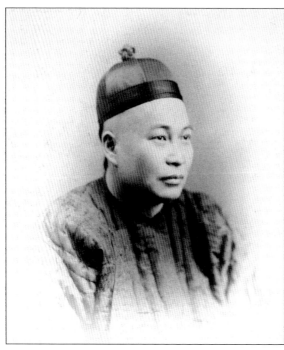

Charlie Tze Hong worked as an agent with the Zee Tai Company, the most prominent Chinese mercantile company in Port Townsend. The company, established in 1879, imported Chinese tea, china, rice, and opium and also contracted many of the Chinese laborers working in the Northwest at the time. The economic success of Chinese mercantile companies, and their contributions to the Port Townsend community as a whole, helped to quell racism and promote cooperation. By 1890, the Chinese population of Port Townsend had risen to an estimated 1,500 people, about one fifth of the total population. The Zee Tai Company folded in the 1930s.

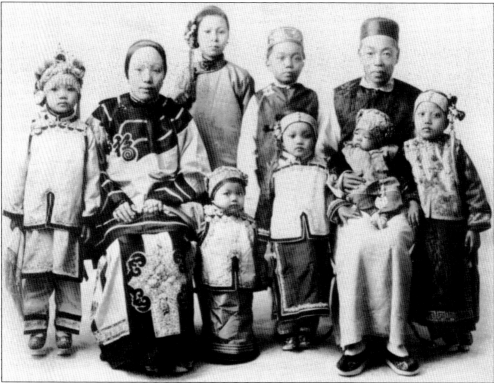

The Chinn Kee family, pictured here, include Lucy, Emma, John, Elsie, Alice, Li Shee Chinn, Turui Kim, Tom, and Chinn Kee. Dressed in traditional embroidered clothing, the family sits for a portrait in Seattle in 1912.

An unidentified Chinese girl sports a traditional costume for a portrait in a Port Townsend studio.

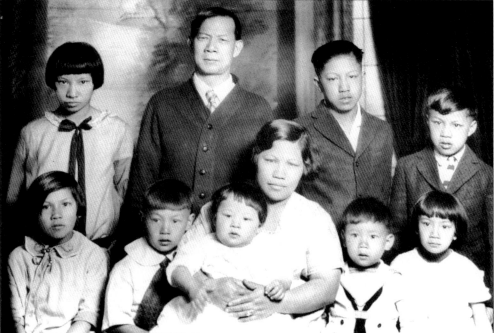

Posing for this c. 1920 portrait, the Wah family, from left to right, are (first row) Lillian, Ellis, George, LeeShee, Calvin, and Mary; and (second row) Nellie, Joe, William, and Mickey. By the 1920s, the racism toward Chinese immigrants that inspired the Chinese Exclusion Act of 1882 had begun to die down. Port Townsend had a reputation for relatively tolerant attitudes toward its Chinese residents.

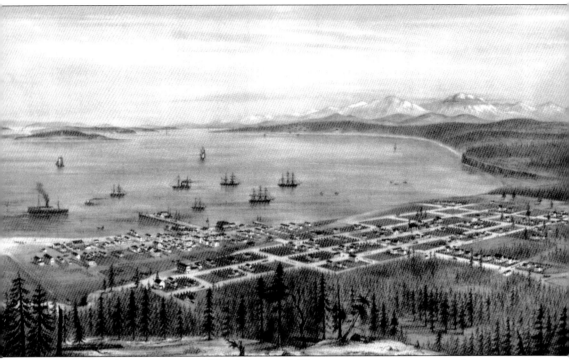

Here is a bird's-eye view map of Port Townsend. The panoramic map was a popular cartographic form used to depict U.S. and Canadian cities and towns during the late 19th and early 20th centuries. Known also as bird's-eye views, perspective maps, and aero views, panoramic maps are non-photographic representations of cities portrayed as if viewed from above at an oblique angle. Although not generally drawn to scale, they show street patterns, individual buildings, and major landscape features in perspective.

Three

VICTORIAN SEAPORT

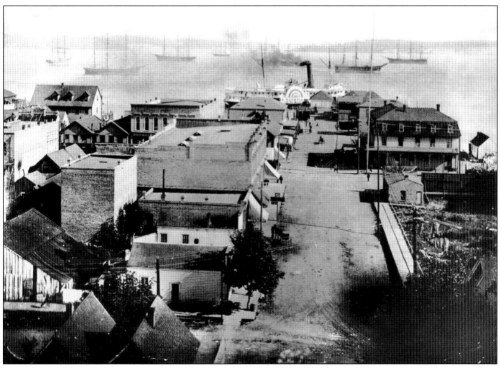

When Port Townsend was officially founded in April 1851, the native people had been enjoying the natural resources of what they called "Kah Tai" for centuries. They may have seen or heard of the various European ships that had visited the area since 1592 in the course of exploring, whaling, or trading for furs, but they probably didn't notice when, in 1792, Capt. George Vancouver and his crew rowed their yawl briefly into the bay and named it Port Townshend Bay for a British marquis. Here the steamboat *Olympia* docks at Union Wharf during Port Townsend's glory days as a Victorian seaport.

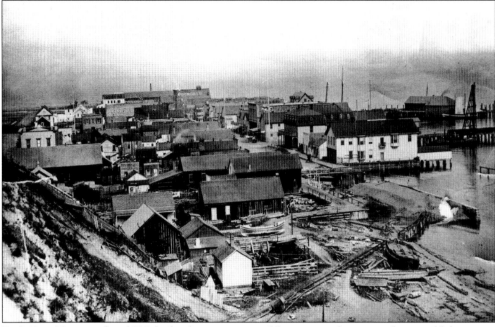

Early Port Townsend, *c.* 1880, lacks the ostentatious Victorian architecture that would dominate Water Street in the coming years.

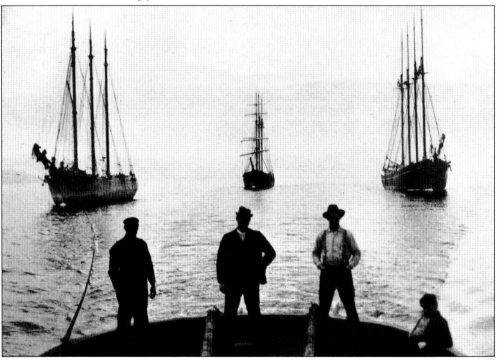

Sailing ships would lose their speed in the Strait of Juan de Fuca and Puget Sound. Port Townsend's tugs and towing operations were critical in the race to transport goods rapidly and cost-effectively. Pictured here are the sailing vessels *Courtney Ford, Portland,* and *Eric,* in tow. At the tug's stern is Capt. H. H. Morrison, center, on a Puget Sound Tug Boat Company tug.

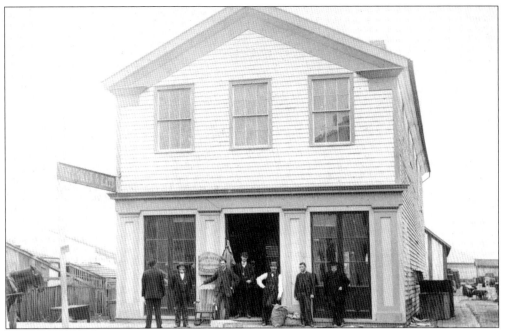

In 1861, German immigrants Sigmund Waterman and Solomon Q. Katz established the Waterman and Katz mercantile, which would become one of the more financially successful businesses in early Port Townsend history. Pictured is the original store building at Water and Quincy Streets.

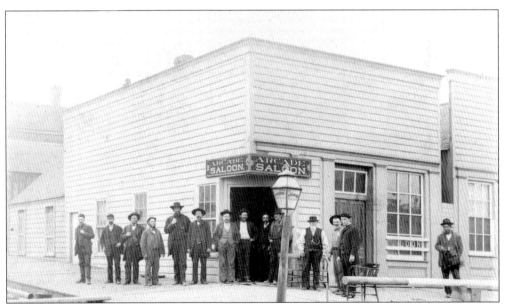

Sailors—joining loggers, soldiers, miners, and farmers in the search for entertainment, camaraderie, and work—converged on Port Townsend's bars along Water Street and Front Street (formerly the boardwalk along the wharves of the waterfront). The bar clientele was typically transient and often on a spree after a long stint in service. The Arcade Saloon served the liquor-related needs of many Port Townsend men until its destruction in a fire on September 24, 1886.

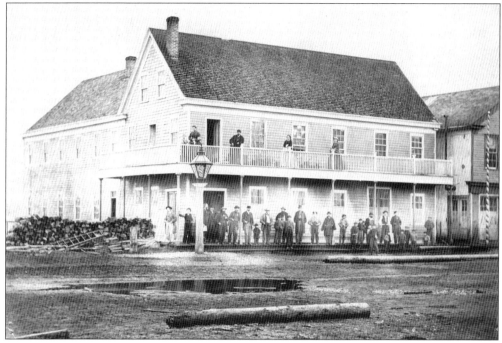

The Pioneer Hotel (later the Cosmopolitan Hotel) on the southwest corner of Water and Adams Streets opened in 1858. At first it accommodated "the best people of the land," as the *Leader* newspaper put it in 1900. When the Central Hotel was built, however, the best people flocked to this new establishment, leaving "roughs and toughs" to the Cosmopolitan, which became a sailor boardinghouse. The same newspaper article claimed that at least half a dozen murders occurred inside the hotel and more outside on the street. Here lodgers gather on the porch on a slightly snowy day in 1865.

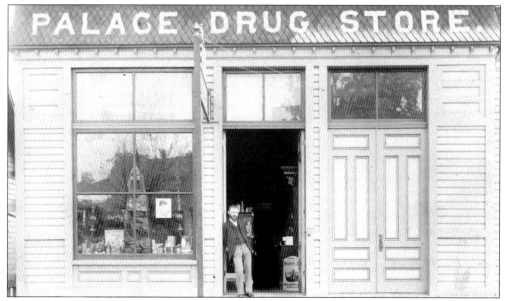

Dr. Louis B. Kuhn, a druggist and government physician, is pictured in the doorway of his Palace Drug Store in 1889. The building also housed the Good Templars' hall upstairs.

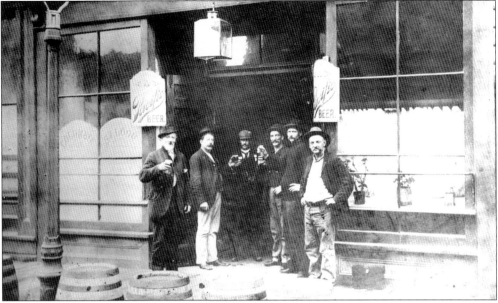

The Columbia Saloon, owned by Mike DeLeo and a handful of fellow Italian immigrant partners, was the site of many a rollicking good time and an occasional shoot-out from its opening around 1898 until its closure with the advent of Prohibition.

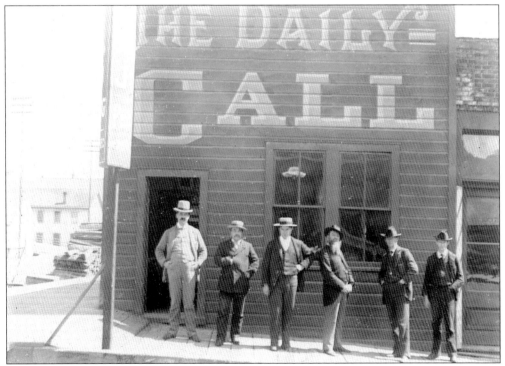

The men in charge at the *Daily Call* stand outside their office. The intrepid newsmen, from left to right, are J. C. Pringle, editor; Frank F. Meyers, foreman; F. A. Willoughby, job foreman; J. A. Kuhn, attorney (also a local real estate magnate and famed clambake host); W. T. D. Hutchinson, business manager; and J. K. Willoughby, pressman.

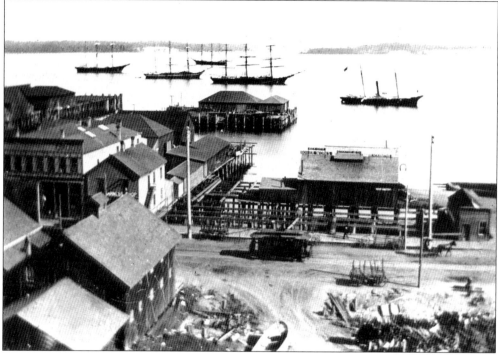

Trolley cars and horse-drawn wagons dominated Water Street as three-masted sailing ships dominated Port Townsend Bay in this early photograph, taken from the bluff uptown.

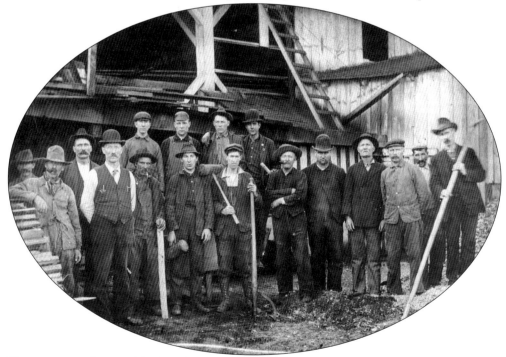

These men, employees of the Eisenbeis and Tucker Brick Plant at Point Wilson, labored hard to create the materials for many of Port Townsend's historic buildings.

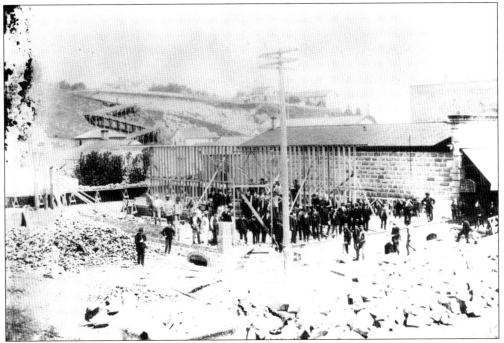

This photograph of the construction of the McCurdy Building at Water and Taylor Streets shows the Adams Street "zigzag" ascending the bluff in the background. These wooden stairs linked the bustling downtown to the more refined uptown residential district.

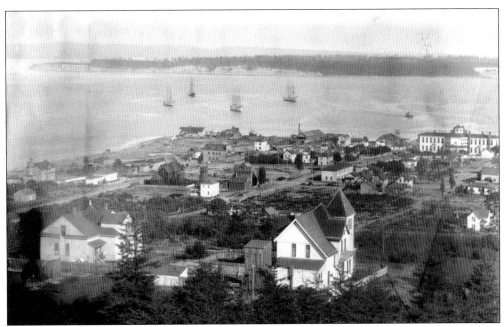

This view overlooks part of the uptown residential district—Point Hudson, Port Townsend Bay, and Marrowstone Island. The large, white building on the right was the Marine Hospital, a federal facility for sailors.

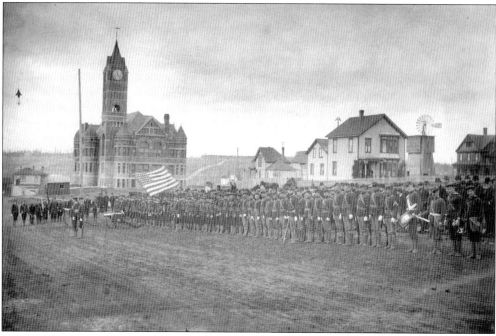

In 1892, three grand civic structures were completed in Port Townsend. The Jefferson County Courthouse, with its clock tower, still serves as the seat of county government. Here an army battalion from a nearby fort drills in the foreground.

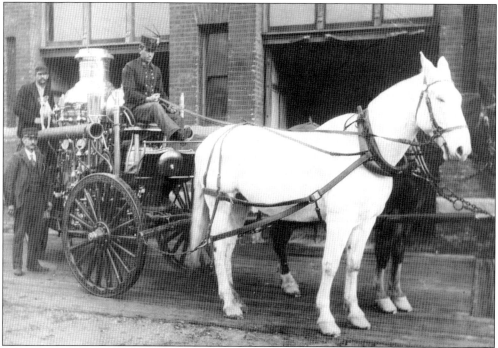

Firemen with a horse-drawn water pump in front of the fire department at Port Townsend City Hall are identified as follows: driver Frank Gore; Ed Christian, standing in back; and John Shade, on the ground.

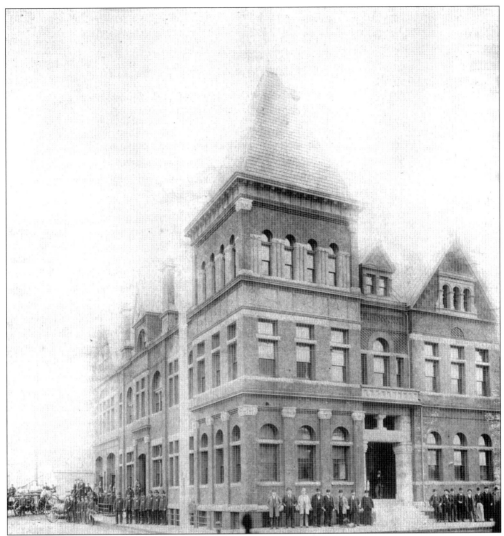

Notable Port Townsend citizens attend the opening of the brand-new city hall in 1892. The grand three-story brick building replaced a small, wooden structure at the same location on the corner of Water and Madison Streets. The building housed city offices, the municipal courtroom, city council chambers, fire hall, firemen's quarters, and, in a still-intact dungeon-like basement, the city jail.

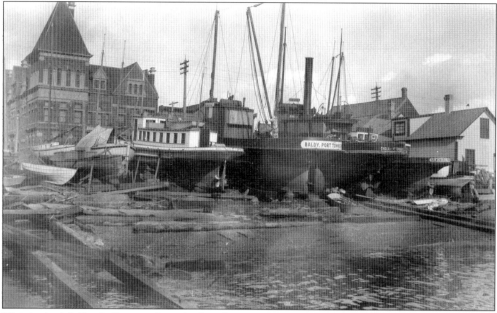

This is the McCurdy Boatyard on the beach across Water Street from city hall.

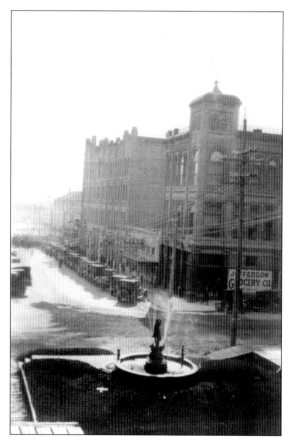

The Haller Fountain, with its statue of Galatea, was unveiled on Labor Day in 1906. It graces the base of the Taylor Street stairs, which provide access to the uptown residential district. The Mount Baker Block and the Rose Theatre stand majestically on the right.

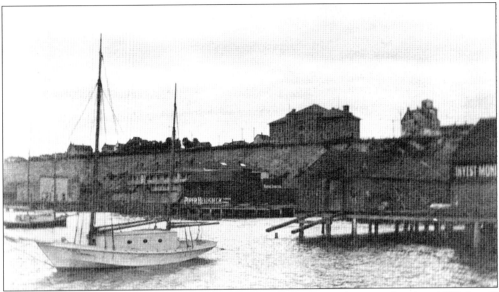

On the bluff above Water Street, the federal custom house was also completed in 1892. It still serves as Port Townsend's post office. The James House is to its right and a huge Masonic hall was to the rear. The sailboat *Comfort* sits peacefully at anchor.

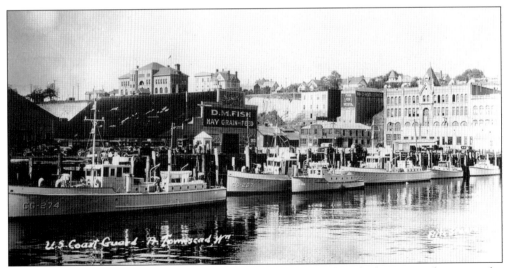

United States Coast Guard vessels are pictured at Fish's Dock with the custom house on the bluff above.

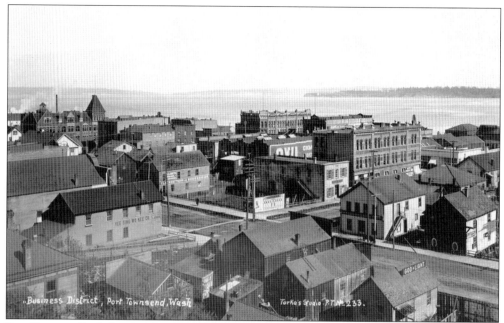

Port Townsend's skyline in the city's "boom" days featured many of the same buildings that are present today, including a brand new city hall (far left with peaked roof).

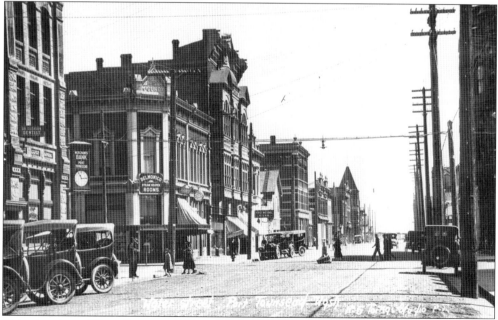

This view down Water Street, c. 1917, includes the Mt. Baker Block, the Delmonico Hotel, the Merchant's Bank, and city hall, with its original steeple roof.

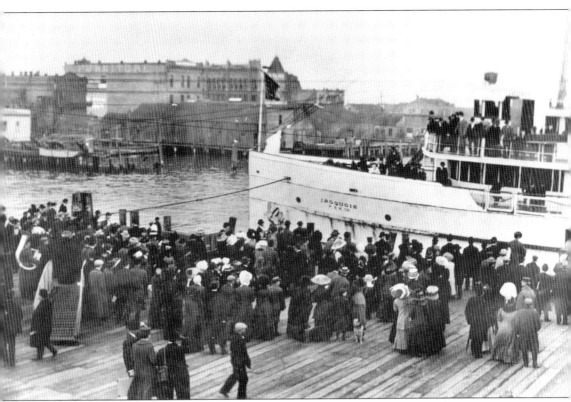

The *Iroquois* takes on passengers at Union Wharf in downtown Port Townsend.

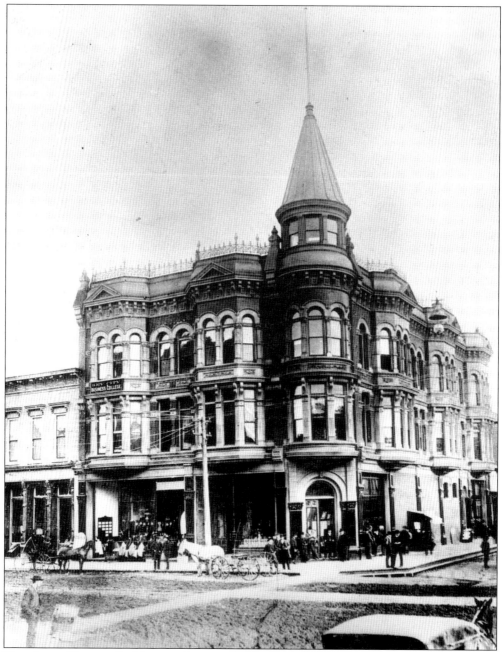

The elegant Hastings Building was home to the Key City Business College on the second floor. Note the wooden sidewalks and dirt street. The Bartlett Building is to the left.

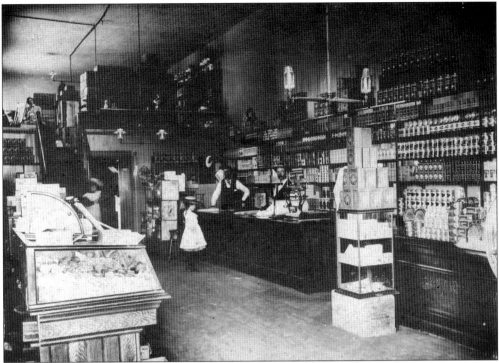

The Wanamaker and Mutty Grocery was a tenant in the old Aldrich's Building uptown from 1907 to 1918. Ira Wanamaker is pictured at the counter.

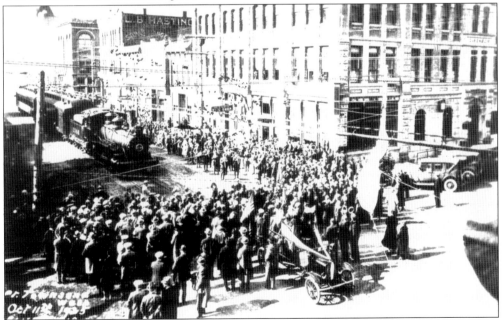

A trolley rumbles down Water Street, year unknown. An excited crowd greets the first steam engine on Water Street on October 11, 1925. The event coincided with the first day of auto ferry service between Port Townsend and Seattle. Though the events were much celebrated, neither transportation service still exists.

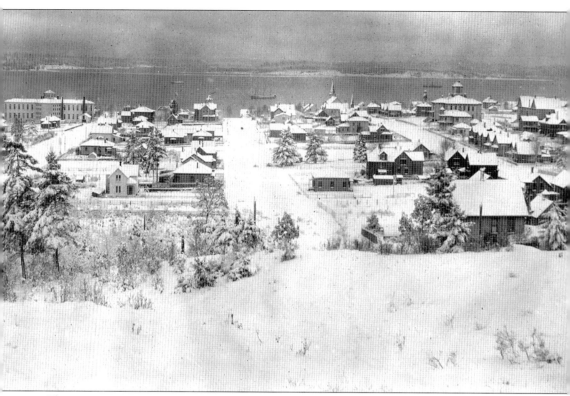

This is a rare snowy view of uptown Port Townsend from Morgan Hill. The U.S. Marine Hospital is the large building to the left and the Central School is the large building to the right.

Four

FORTS

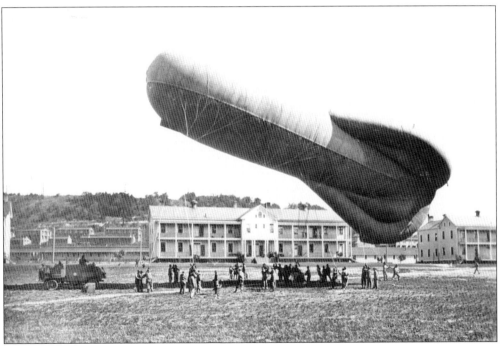

The U.S. War Department initiated an elaborate system of coast defenses in 1896 to protect the entrance to Puget Sound. The "Triangle of Fire" included Point Wilson near Port Townsend, Marrowstone Point across the bay from Port Townsend (Fort Flagler), and Admiralty Head on Whidbey Island (Fort Casey). The 14th and 24th Balloon Companies used this "sausage" dirigible for observation in and around Fort Worden in 1920. Missions included measuring atmospheric conditions and photographing the surrounding area from above. The 2nd Balloon Company, stationed at Fort Casey, had seen combat in World War I, spending 244 days on the front and spotting 121 enemy planes.

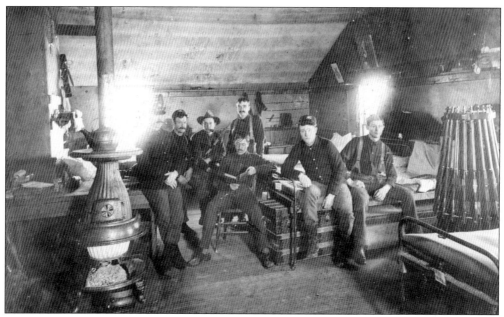

Fearing hostilities from local American Indians, citizens appealed to authorities in Washington, D.C., for protection. In 1856, Maj. Granville Haller, American Indian fighter, and Company No. 1 of the 4th Infantry cleared a site about five miles from Port Townsend. They used timbers hewn by hand and plaster from clam shells to construct their buildings. Here men gather around a good book in the barracks at Fort Townsend.

These barracks at Fort Townsend burned to the ground on January 2, 1885, when one of the kerosene lamps exploded and ultimately sealed the fort's demise as a military institution.

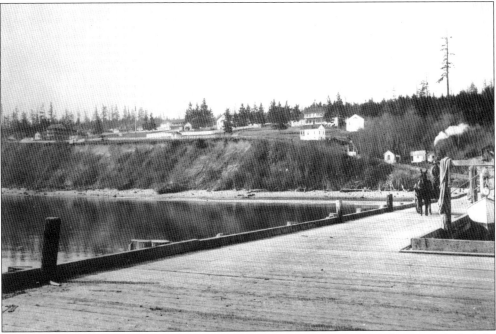

With peaceful relations with the local natives, Fort Townsend served primarily as a supply dock for boats from Fort Steilacoom. The soldiers and their families were a welcome addition to the Port Townsend community, but by the 1890s, it was clear there was no military need for the post.

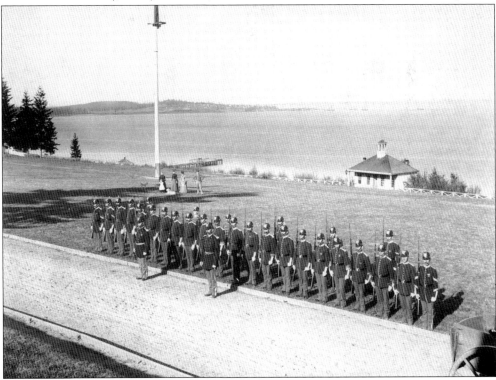

A National Guard battalion stands on the dock at Fort Townsend prior to 1889.

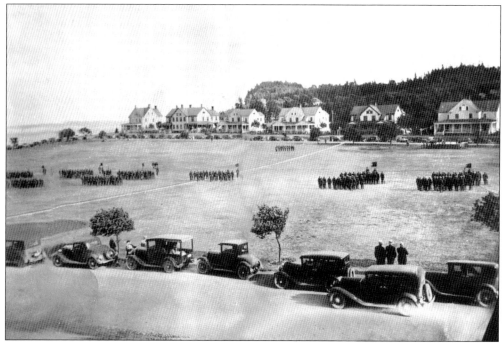

Soldiers drill on the Fort Worden parade ground.

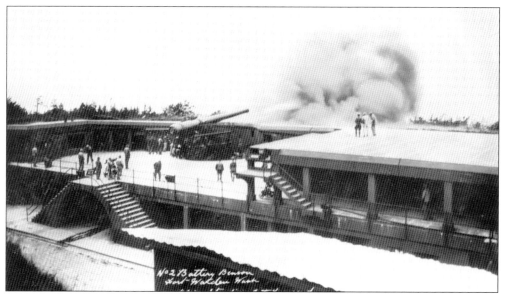

Here is a rare view of a 10-inch disappearing gun in action. Reinforced concrete formed the base and protective walls for guns mounted on disappearing carriages. These battery emplacements were massive, yet simple in design, flowing into the landscape.

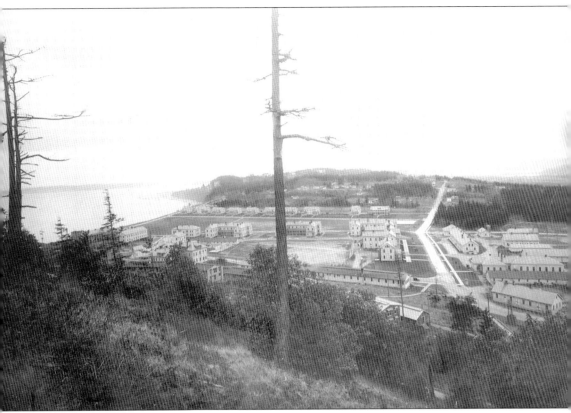

In the U.S. Harbor Defense System's "triangle of fire," Fort Flagler was the planned headquarters, but Port Townsend boosters were tenacious and, when the first troops arrived in 1902, Fort Worden was declared Coastal Defense headquarters. Construction continued on the fort until 1911, gradually building a compound of barracks, administrative buildings, and gun emplacements that would endure and gain National Historic Landmark District status. In 1919, when this photograph was taken, the military presence at Fort Worden had been reduced to 50 officers and 884 enlisted men.

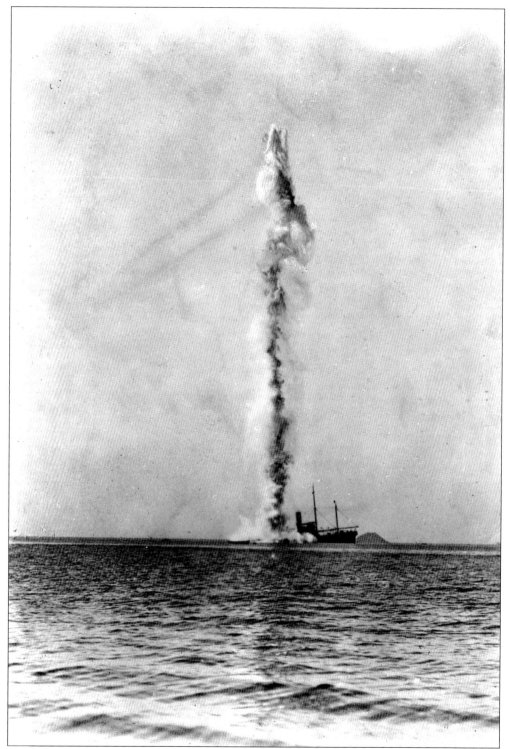

The mine-planting vessel *Major General J. Franklin Bell* observes a coast artillery mine explosion in 1922.

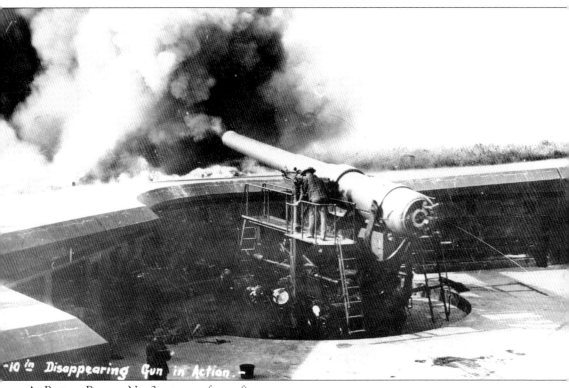

-10 in Disappearing Gun in Action.-

At Battery Benson No. 2, a team of men fire a cannon.

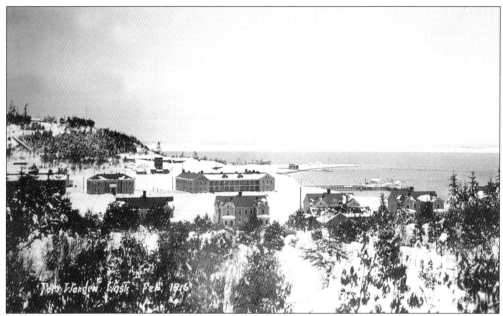
A tranquil snow rests on Fort Worden in February 1916.

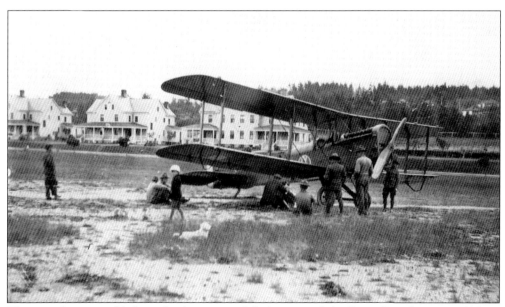
This aeroplane most likely made observational flights around the Puget Sound area, *c.* 1920.

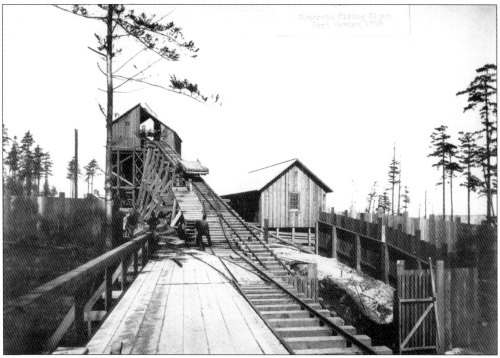

The concrete mixing plant at Fort Worden, constructed in 1897, furnished the fort with much-needed building material.

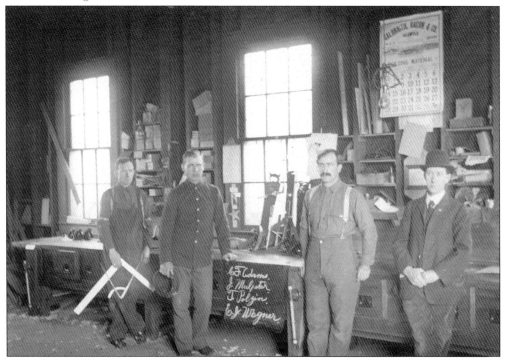

C. F. Adams, J. Mulpeter, T. Polzin, and E. J. Wegner, pictured here in their shop, fulfilled the carpentry needs of Fort Worden.

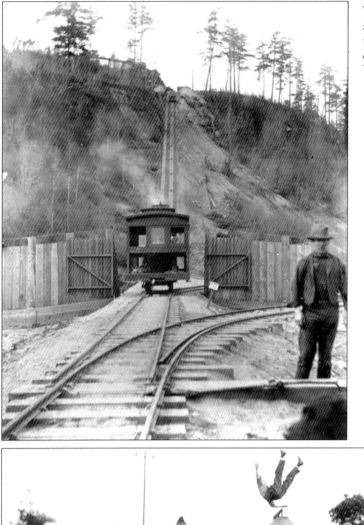

This tramway served as convenient transportation over the occasionally difficult Fort Worden terrain.

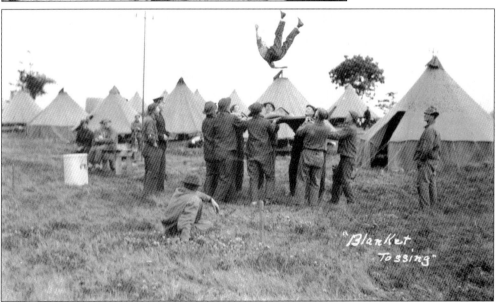

Soldiers toss one of their own skyward with a blanket's help, possibly as part of a Field Day game.

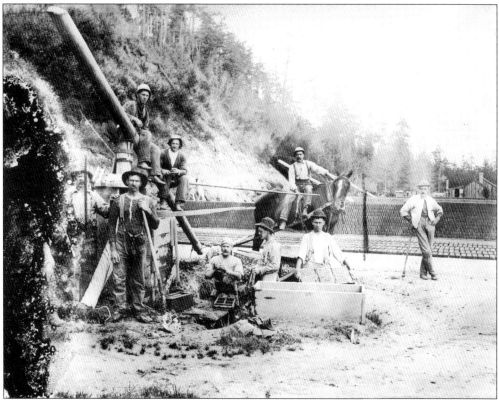

These men, laboring at the brick plant at Fort Worden, were not held to such a strict dress code as their soldiering counterparts.

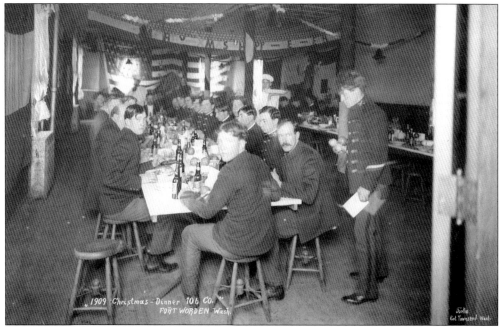

The 106th Company consumes a beer-heavy Christmas dinner at Fort Worden in 1909.

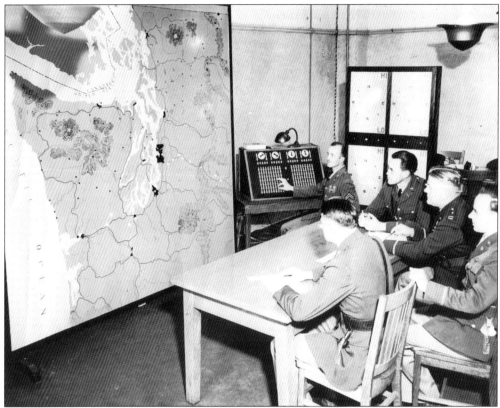

The Fort Worden Operations Center featured a state-of-the-art interactive map of western Washington, operated here by Corporal Koch.

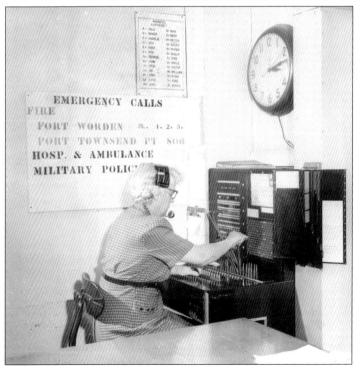

Telephone operator Daisy Askin fields calls in the Fort Worden headquarters building, post signal section, in 1953.

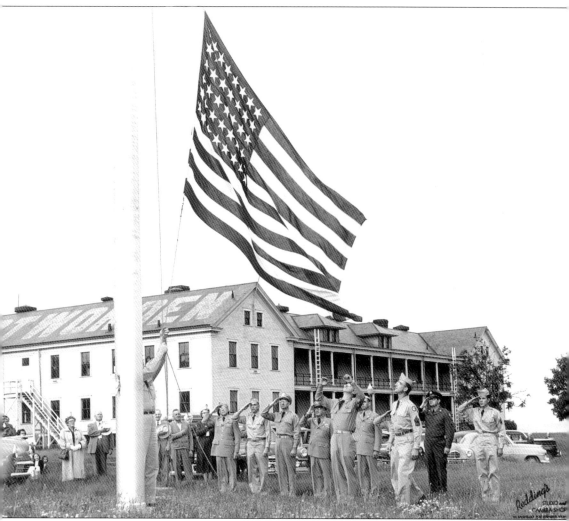

This 1953 photograph shows the last flag being lowered at Fort Worden as a military installation.

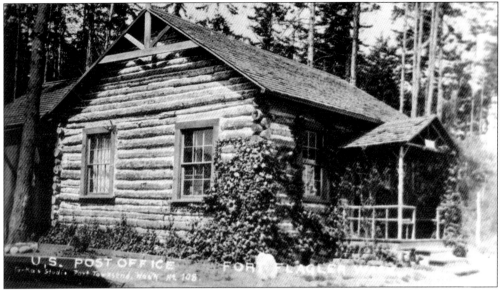

The Fort Flagler Post Office was established in February 1900 with Carl Triol as postmaster. The steamer *Prosper* delivered mail to the fort from Seattle.

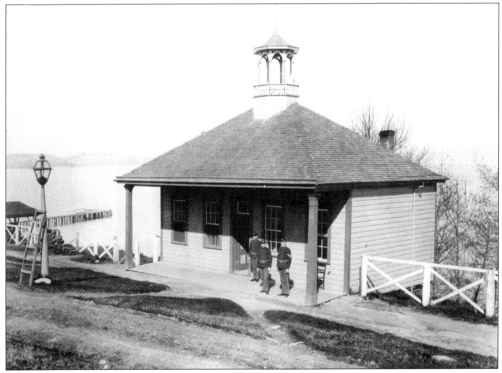

E. A. Mackay of Seattle constructed the Fort Flagler Post Guard House in 1899; it cost $2,105.15.

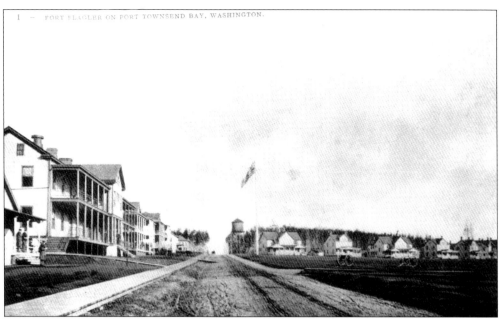

This view down the main road of Fort Flagler reveals administrative offices, the parade ground, officers' homes, the flag, and the water tower.

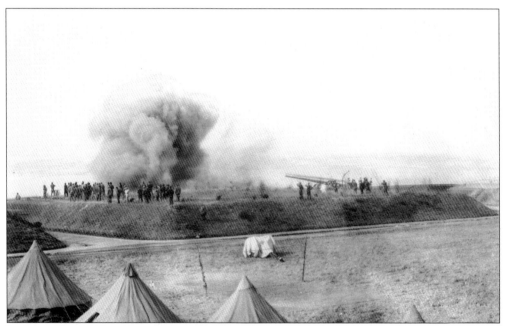

In September 1902, soldiers at Fort Flagler train in marksmanship using a rapid-fire battery of guns, shooting moving targets towed by a steamer.

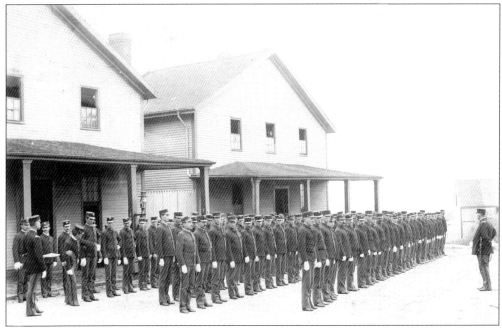

In 1903, John L. Hughs performs a company inspection at Fort Flagler.

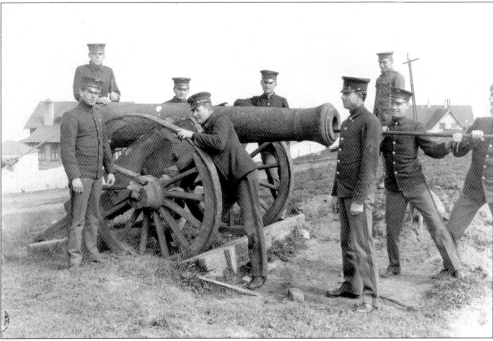

Men load a cannon at Fort Flagler.

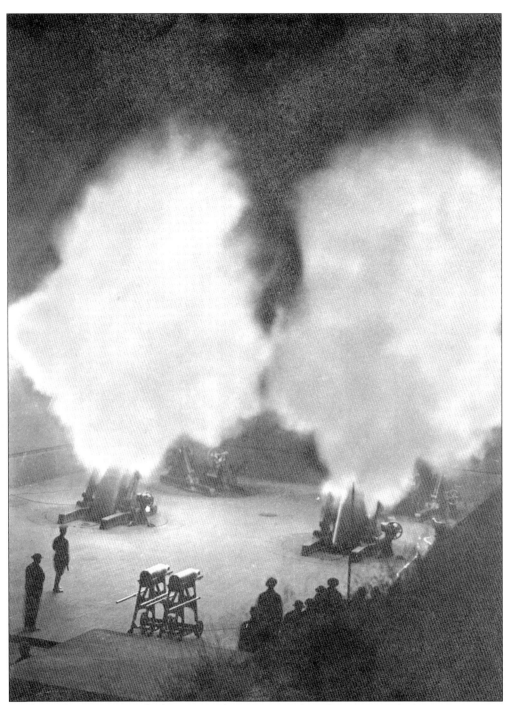

Twelve-inch mortar guns discharge at night, to spectacular effect, at Fort Flagler.

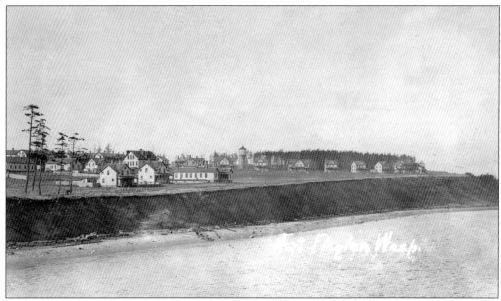

The officers' quarters and parade ground at Fort Flagler rest on the bluff above Admiralty Inlet.

John C. Phillips (second from left) was in charge of the engineer's office at Fort Flagler. The engineers were: ? Steele, J. C. Phillips, John "Jack" Hartnacke, and Harold Baker (son of Rev. Dr. Brooks O. Baker).

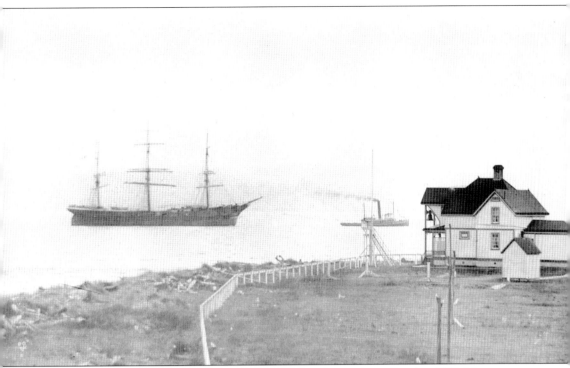

The Marrowstone Lighthouse began as a red lens on a white pole in October 1888. Nine acres were set aside around the light for the lighthouse in 1895, the year of Fort Flagler's deactivation. In 1896, a fog bell was added, and in 1962, the lighthouse became automated.

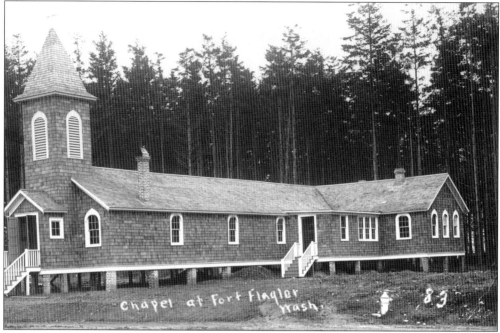

The Fort Flagler chapel, pictured here in 1915, was torn down in 1931.

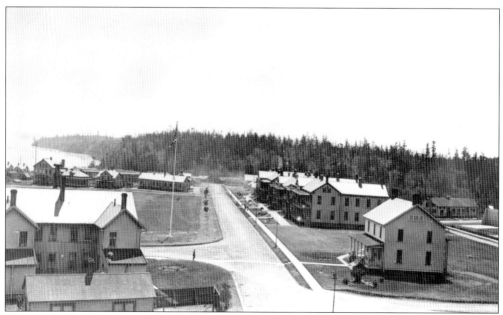

Most of the buildings at Fort Flagler were torn down in 1936 due to dry rot.

Five

PORTS, BAYS, AND ISLANDS

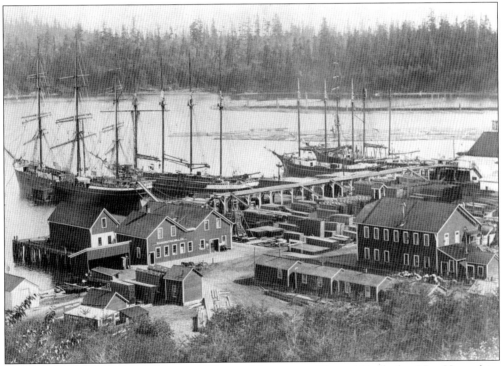

Port Hadlock was a mill town born in 1870 out of the vision of Samuel Hadlock, a New Hampshire native who came to Oregon on a wagon train in 1852. The sawmill struggled until the late 1880s, when it was purchased by San Francisco capitalist W. J. Adams and operated as part of the Washington Mill Company. It maintained an average daily production rate of 150,000 board feet of lumber until its closure in 1907. W. J. Adams, owner of the company, was grandfather to the celebrated landscape photographer Ansel Adams. Pictured here in 1903, the mill burned down in 1913. Two of the remaining buildings are now home to the Northwest School of Wooden Boatbuilding. On the right is the present-day Ajax Café.

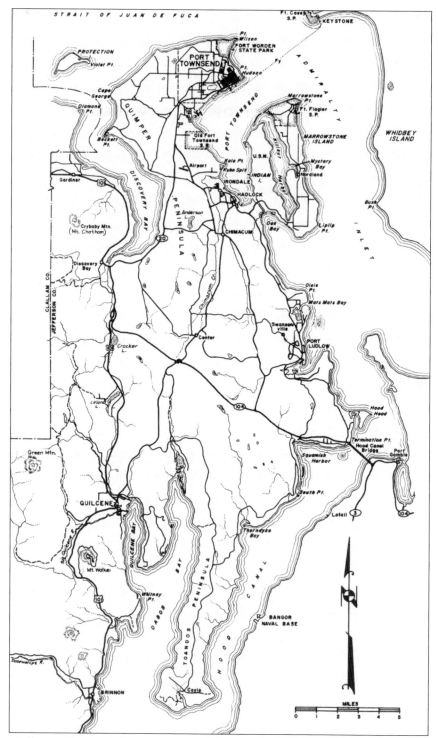

Eastern Jefferson County is home to most of the people in the county. The rugged Olympic Mountains in the center of the Olympic Peninsula form a barrier between the small towns in the east and the isolated settlements to the west.

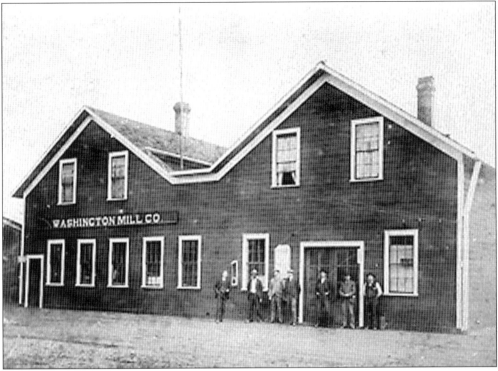

Sam Bugge (right) and others stand proudly before the offices of the Washington Mill Company.

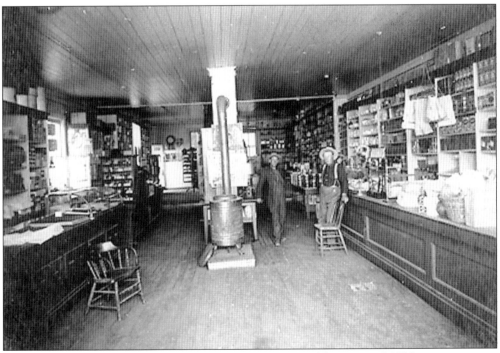

Sam Bugge managed the Lower Port Hadlock Store, pictured here around 1900.

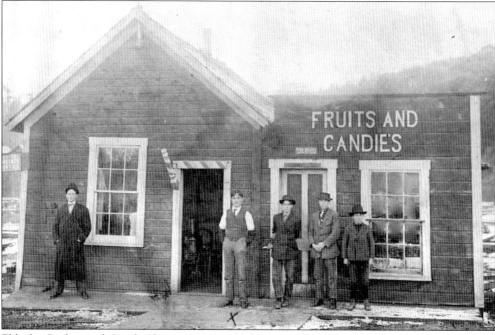

Eldridge Barber and Candy Shop was a sweet addition to Port Hadlock's local economy. James Eldridge, proprietor, stands to the right of the striped front door of the barber shop.

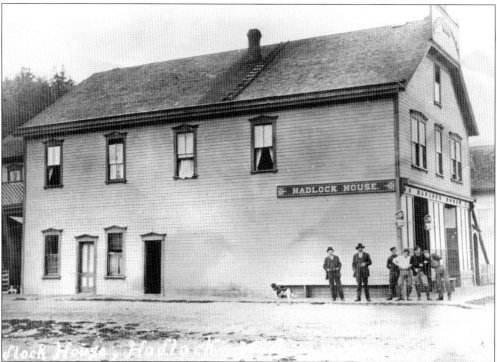

In 1906, William and Lena Galster purchased the Hadlock House from Humphrey Oldfield. They lived on the second floor; the first floor was a saloon and the site of many a barroom brawl. Here a handful of unidentified roustabouts pose on the corner.

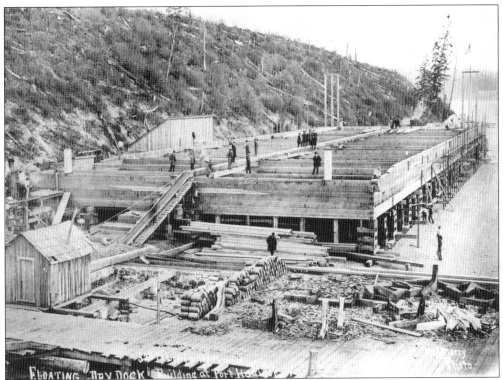

This floating dry dock, erected in 1891 in Port Hadlock, was 325 feet long and 100 feet wide.

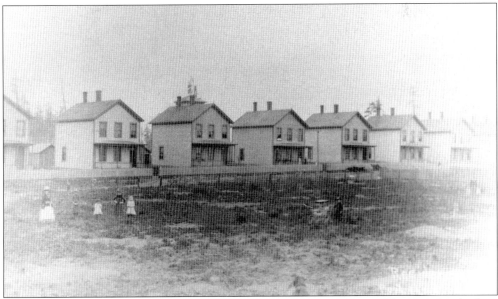

A residential neighborhood in Lower Port Hadlock, *c.* 1900, most likely mill housing, foreshadows the architecturally unimaginative housing developments common in the coming century.

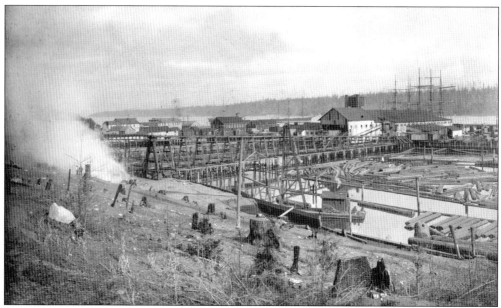

The Washington Mill Company employed 125 men at a daily wage of $1.25 plus board. It supplied the lumber used to build Forts Casey, Worden, and Flagler.

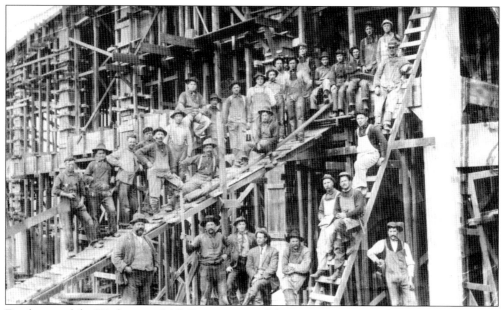

Employees of the Washington Mill Company stand for a portrait on March 18, 1896.

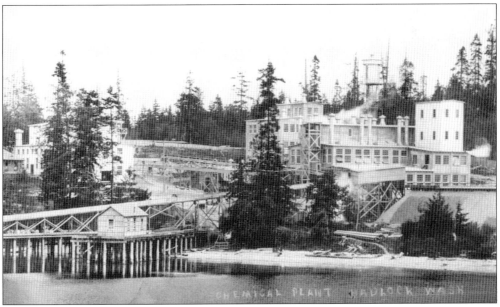

Using imported French distillery equipment, the Classen Chemical Company's alcohol plant, located south of Port Hadlock, converted sawdust into 190-proof industrial ethyl alcohol and bastol, a substance used in cattle feed. The company, started by W. J. Adams after his Washington Mill Company fell on hard times, abruptly failed and closed its doors in 1913.

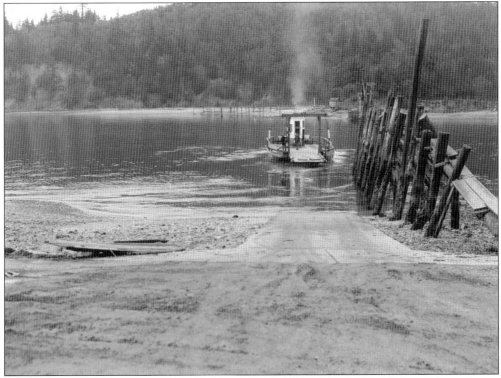

Nordland, the ferry from Indian Island to Port Hadlock, was built in 1926 by William Sehrs in Lower Hadlock. The vessel, 58 feet in length, could hold up to six cars plus passengers and freight.

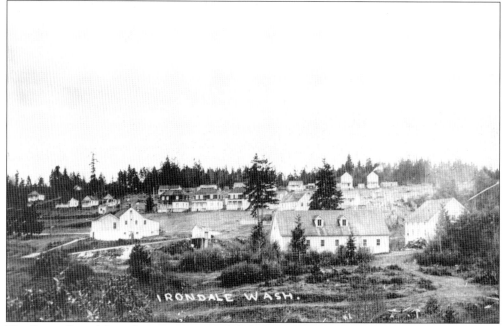

The Puget Sound Iron Company in Irondale began producing pig iron in 1879 and was the only iron smelter in the state at the time. Vessels and engines were made from the Irondale ore that lay beneath present-day Chimacum. Unfortunately the ore was of poor quality. The dream of steel was reawakened in 1909 when a Seattle developer named James Moore organized the Western Steel Corporation and bought the mill. He acquired 1,500 acres that included a mile of waterfront property. Irondale boomed and then went bust when the mill closed in 1911. Two fires in 1914 burned most of the town.

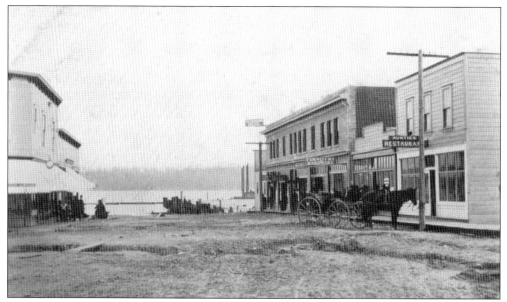

Moore Street was the central business district in Irondale, with brick hotels, bank, saloons, and stores. It was named for James A. Moore, the early investor in the town.

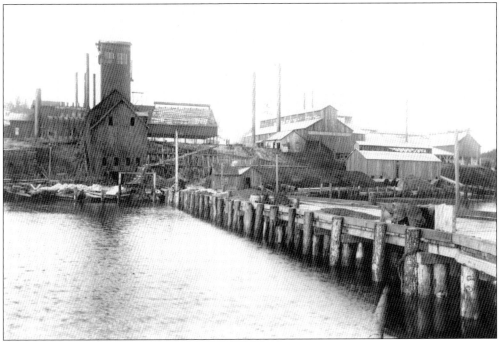

In 1909, James A. Moore invested $40,000 in the Irondale Steel Plant, expanding it to include three blast furnaces, two rolling mills, and an average daily production figure of 300 tons. Irondale boomed and then went bust when the mill closed in 1911. In 1912, the equipment was sold to Pacific Coast Steel Company of Seattle. The plant reopened briefly in 1917 due to the demand for iron during World War I, only to close again in 1919.

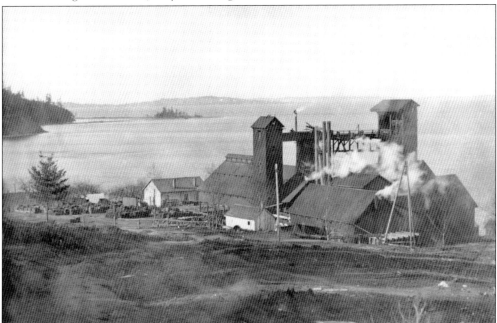

In 1902, the Irondale Plant was the only smelter in the state. The production of pig iron employed 325 men.

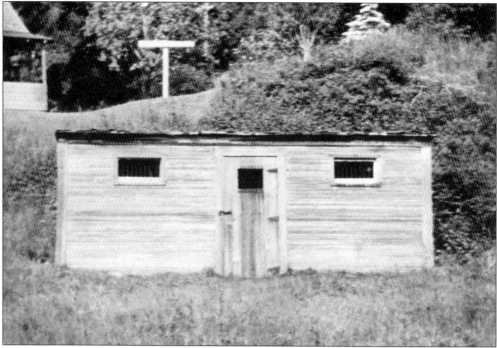

William H. Merrick built the Irondale Jail, located at the foot of Moore Street, in April 1911 for $144.50. The structure features two small, high-barred windows, two cells, a "solitary," and a tiny jailer's office next to the door. Two-by-fours were laid on top of each other to form the walls, and the roof is made of split shakes. Remarkably the building still exists but is gradually sinking into the ground.

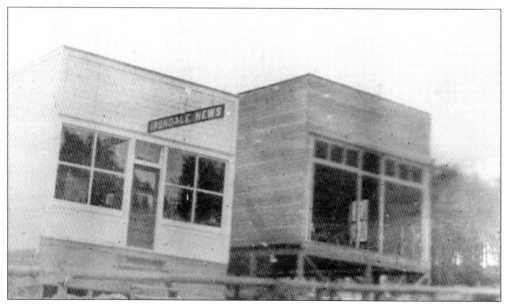

The *Irondale News*, a weekly paper, first came off the presses on February 5, 1910, with Charles G. Campbell as editor. Their motto was "Irondale first, last and all the time."

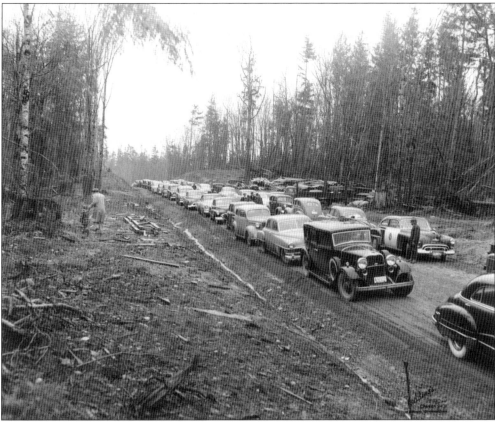

In 1952, cars line up to cross the newly constructed Portage Canal Bridge that linked the mainland with Indian Island.

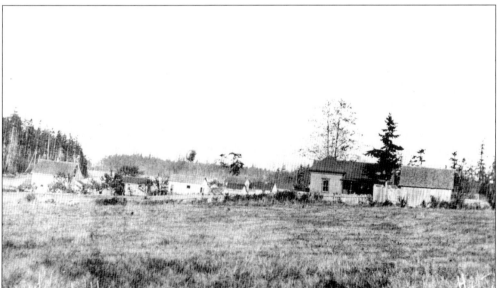

In 1892, Peter Norby, a Norwegian immigrant, founded the community of Nordland on Marrowstone Island. Norby did not settle in the area; this homestead is that of his brother Ole Norby.

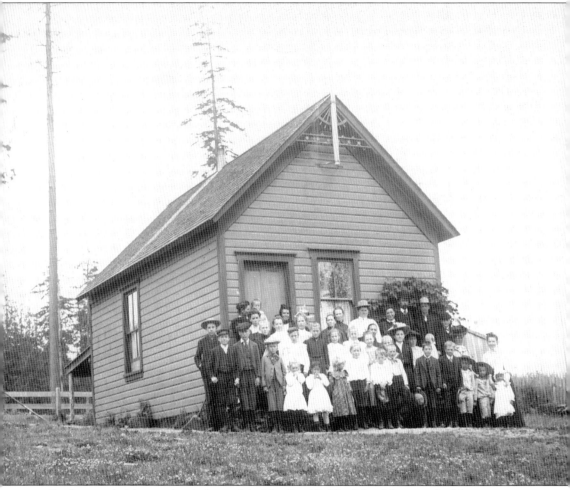

Students and visitors gather in front of the Nordland Public School for an end-of-the-year program on the last day of school in June 1905. Included in the class are several descendants of Nordland settler Ole Norby.

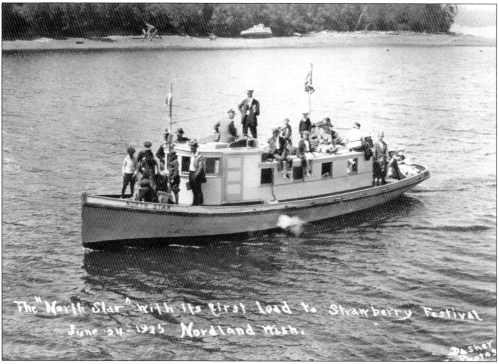

The *North Star* ferries its first boatload of mainland tourists to the 1925 Strawberry Festival in Nordland.

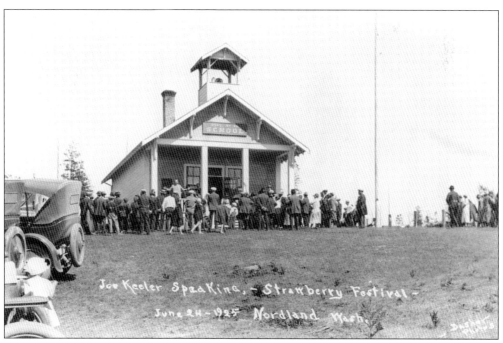

Joe Keeler draws a crowd to the schoolhouse at the Strawberry Festival in Nordland on June 24, 1925.

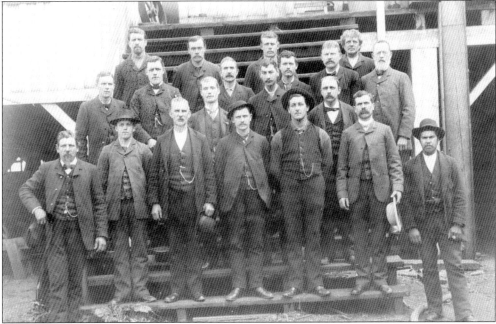

The Port Discovery Lumber Mill was established by S. L. Mastick and Company of San Francisco in 1858. At the time, the mill shipped lumber on 54 vessels, many hailing from exotic ports. More than 300 people lived in the village near the mill.

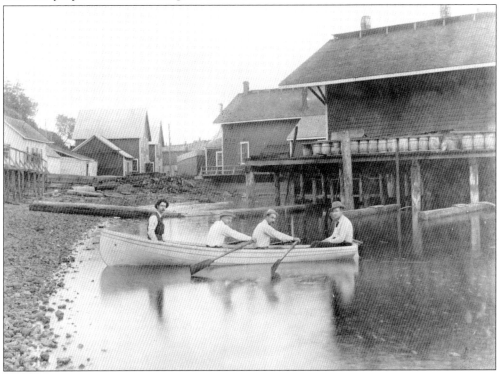

Four unidentified men set off in a canoe by a section of Port Discovery Mill Company employee housing.

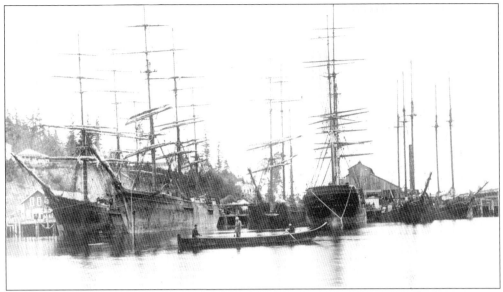

By 1888, workers were cut to part-time, and the Port Discovery Mill Company had new owners in Moore and Smith. The company eventually went bankrupt and sold its timber rights.

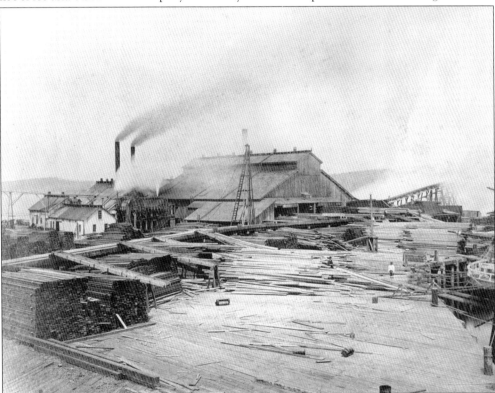

Port Discovery Mill Company vessels sailed out of Port Discovery loaded with timber. Company housing dotted the main street as well as the hills around the bluff. There was a post office and a hotel, and homesteaders from more remote areas traveled to the port for provisions. A Chinatown sprang up behind a ridge, sheltering illegal immigrants and smugglers.

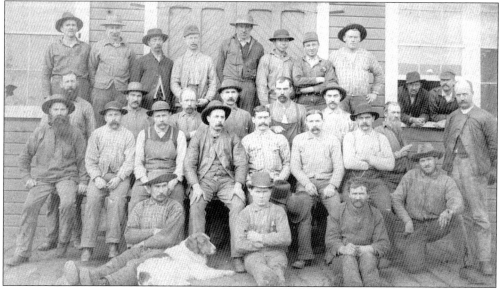
A crew of unidentified Port Discovery mill hands sits for a photograph on September 30, 1890.

In 1965, Stillman C. "Stim" Brown was forced to abandon his logging operation on Discovery Bay due to his failing health. The mill communities of Maynard, Fairmont, and Uncas became ghost towns. Today the old mill site is occupied by the silvered cedar remnants of aged structures gradually collapsing into the bay. Of the mill, only pilings and dilapidated buildings visible at the head of the bay remain.

Rough-hewn traps on the shores of Discovery Bay caught herring.

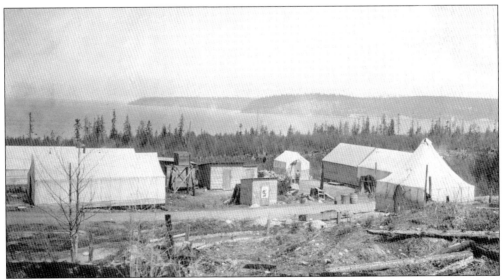

This road camp at Gardiner served laborers in July 1910. Contractor Coyne completed the Gardiner Road, which runs from a point on Port Discovery Bay and connects to Sequim Road.

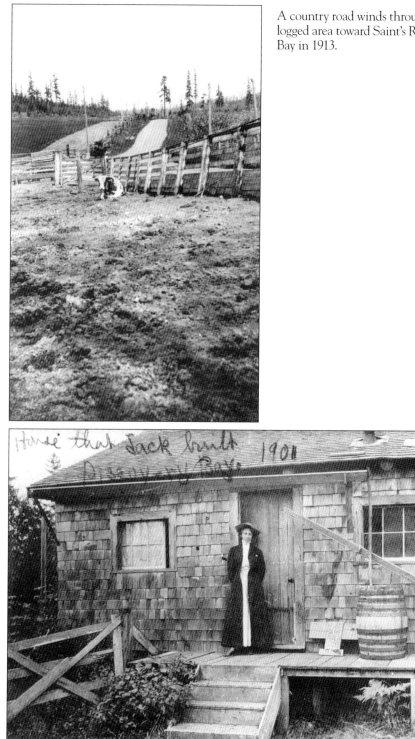

A country road winds through a heavily logged area toward Saint's Rest on Discovery Bay in 1913.

An unidentified woman stands in front of "the house that Jack built" on Discovery Bay in 1901.

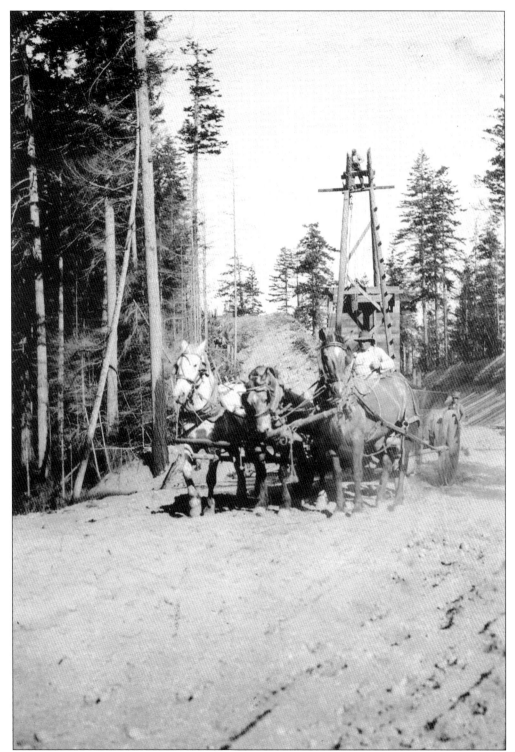

A team of men and horses build the main route out of Port Townsend to Discovery Bay in 1880.

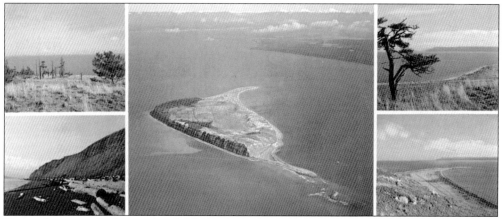

The earliest record of ownership for Protection Island dates to 1861 as bounty land. In the next decade, portions were bought and sold for $1.25 an acre. Henry E. Morgan lived and farmed on the island for a while, until he deeded his portion to his wife, Kate, in 1867. In 1874, Henry sold half of his interest to John Power Sr., who lived there with his family and commuted to Port Townsend every day by rowboat, a 20-mile round-trip. In 1887, Power sold Protection Island for $25 an acre to Henry Morgan and several members of the Bash family. From 1920 to 1928, the Prim family farmed potatoes on the island. Between 1943 and 1945, the island was used by the Harbor Defense system. The island became a wildlife sanctuary and refuge in 1974.

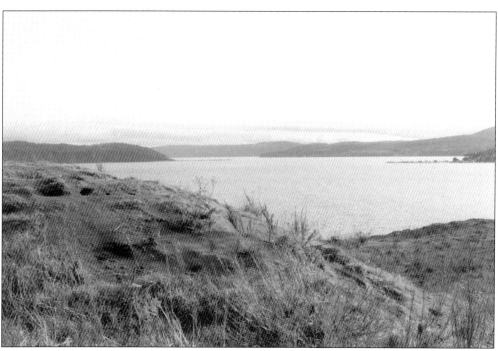

Here is a view from Protection Island.

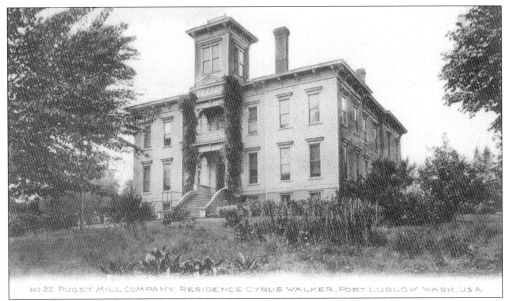

Cyrus Walker, a wealthy, eccentric mill manager, built what he called "the biggest damn cabin on the Sound" in Port Ludlow when his home in Port Gamble burned down in 1885. The mansion featured 12 bedrooms, an elevator, a wine cellar, and a staff of Chinese houseboys. This photograph, used as a postcard and sent to a friend of Walker's in Seattle, was postmarked November 9, 1905.

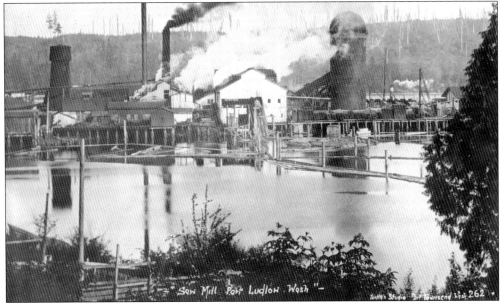

The story of the mill at Ludlow is typical. Initially the wood was easy to access because trees grew right up to the water. Later oxen, horses, and skid roads were required to move the logs to the ships. In 1883, the Puget Mill Company employed 120 men at the Port Ludlow Sawmill, who, with their families, comprised the entire population of the town.

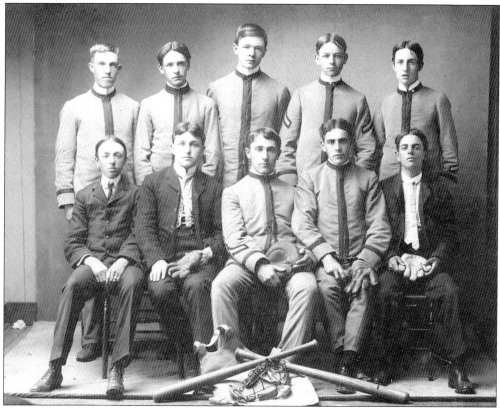

The 1905 Port Ludlow baseball team included future Jefferson County treasurer Sigurd Swanson (first on back row).

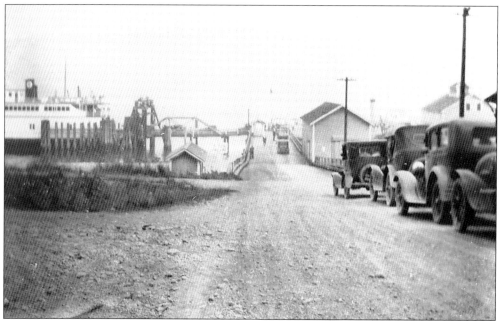

The ferry dock at Port Ludlow greeted ferries from Edmonds and Ballard several times daily.

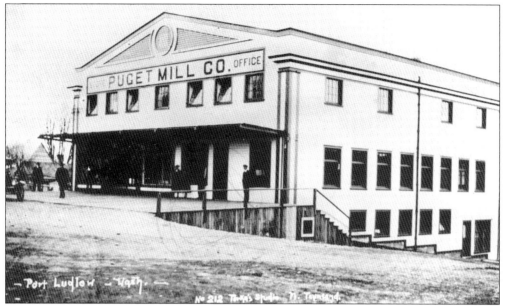

The Puget Mill Company office was the seat of power in Port Ludlow until, after nearly 20 years of inconsistent operation, the mill closed permanently in 1935.

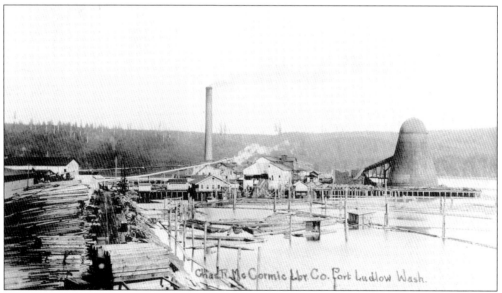

In 1925, the Puget Mill Company became the McCormick Lumber Company, a change that fed one last lumber boom for Port Ludlow before the industry's ultimate demise in the area 11 years later.

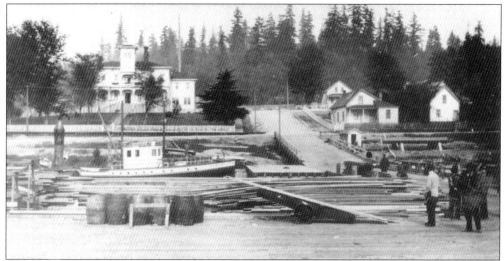

The opulent Cyrus Walker residence overlooks a rugged Port Ludlow shipyard. When Walker retired, the mansion was converted into the Admiralty Hotel and operated until the mill closed permanently in 1935.

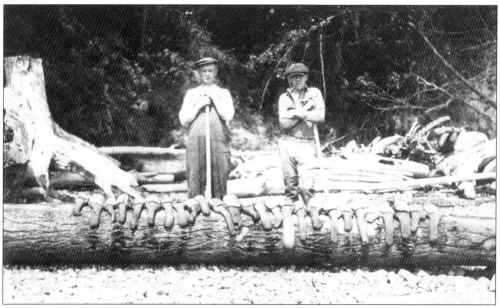

Two unidentified men pose with their geoduck harvest in Shine. The geoduck is an enormous bivalve indigenous to the Olympic Peninsula. Shine is located on the west shore of Hood Canal, near the Hood Canal Bridge, about four miles from Port Ludlow. Logging camps were numerous, and many of the young men worked as longshoremen at the mill at Port Ludlow. Agriculture, in a very small way, supplemented logging and furnished fresh produce for the lumbering families. In the 1920s, the road was built through Shine to Port Ludlow. The town had a little one-room school that went to eighth grade. Prior to 1950, ferry service was provided by Berte Olson and her sons for the Port Gamble–Shine run. For 15 years, she operated the ferry service across Hood Canal. The ferry run was replaced by the first Hood Canal Bridge in 1961.

Six

FARMS AND FORESTS

Robert E. and Betty Heskett moved to this Chimacum farm after their marriage in 1927. In 1945, the remarried Betty McDonald wrote her novel *The Egg and I*. Albert Bishop, of Center, and eight of his children were offended by McDonald's thinly disguised description of their family and unsuccessfully sued. The farmhouse was torn down in 1958.

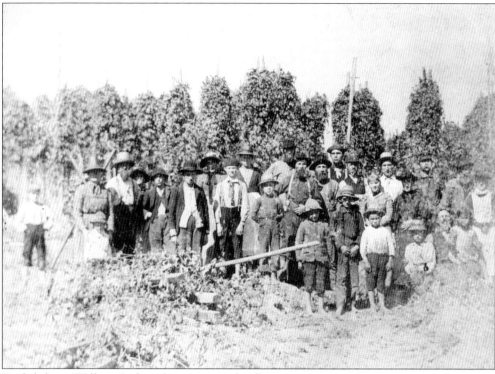

English-born William Bishop Sr., occasional Jefferson County commissioner and prominent patriarch, cultivated a successful hop farm in Chimacum. In the late 1880s, his crop brought in $13,000. American Indian laborers, pictured here with others on Bishop's land, often traveled hundreds of miles to pick hops there and in other communities in Washington State.

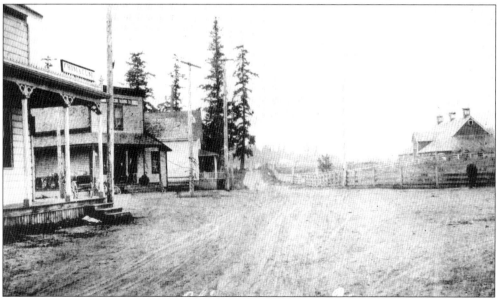

Pictured here, from left to right, the Chimacum Hotel, the Chimacum Trading Post, and the Bishop Farm frame the empty, unpaved roads of Chimacum's commercial center at the end of the 19th century.

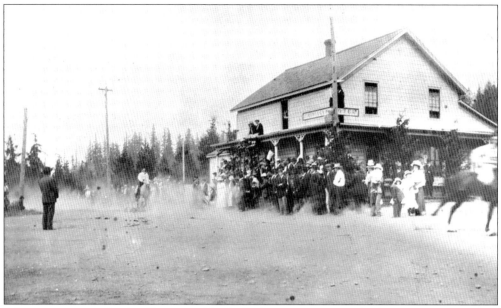

A horse race passing by the Chimacum Hotel affords some excitement for the community's citizens on a dusty Independence Day, *c.* 1900.

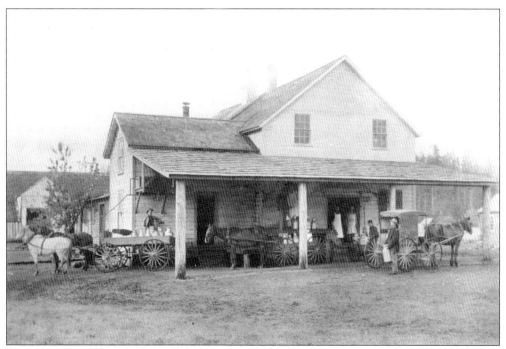

William Bishop Sr. and William Eldridge jointly purchased a farm in 1857 and established the Glendale Dairy. In 1889, cheese production began, and a creamery was added in 1900.

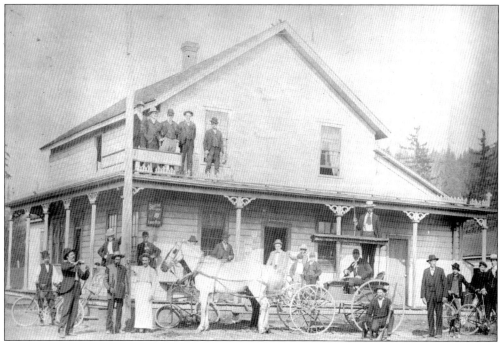

The Chimacum Hotel, built during the area's "boom days" (1888–1889), prospered as a social hub until it was destroyed in a fire on May 3, 1938, while under the ownership of Mr. and Mrs. Nathaniel C. Ingram.

Caleb Bill established a blacksmith shop in Chimacum in 1872, where he and his son, Howard L. Bill, made a variety of iron ship fittings and anchors for small boats. In 1894, Howard took over the shop, having also worked as a blacksmith in Chicago and Irondale.

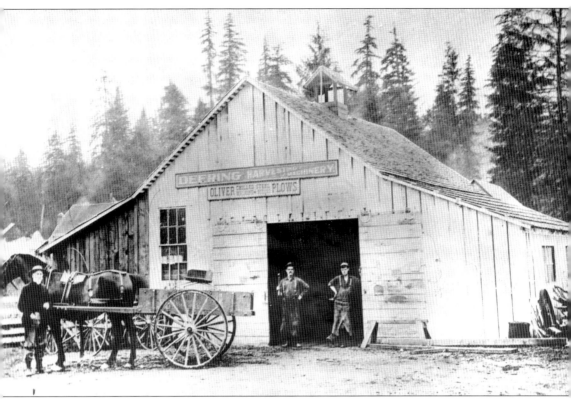

Two unidentified blacksmiths idle in the doorway of Bill's Blacksmith Shop in Chimacum as Caleb Bill tends to a horse.

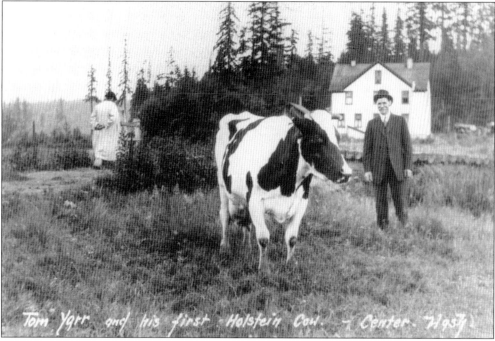

Born in Belfast, Ireland, Thomas Yarr Sr. (in suit and bowler hat) settled in Center in 1891. He is pictured here with his first Holstein cow, *c.* 1915. The man in white is Chimacum farmer William Bishop.

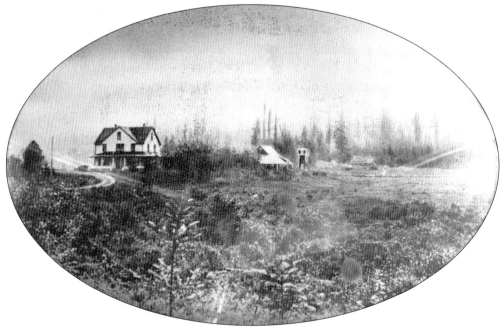

The Thomas Yarr homestead is seen here in Center after 1914. The elder Thomas Yarr was a successful rancher while his son, Tommy Yarr, went on to win All-American football honors as a center at Notre Dame. He gained posthumous acceptance to the American Indian Athletic Hall of Fame.

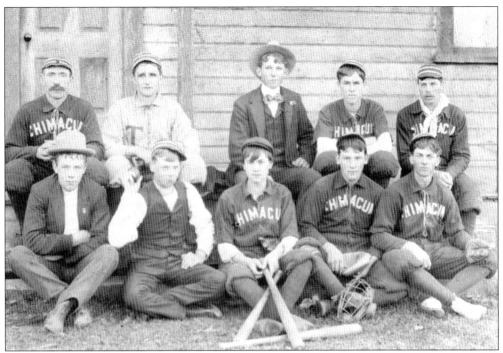

The Chimacum baseball team of an unknown year featured the athletic talents of, among others, Jim Peterson (front, second from left), George Enfield (front, far right), Charles Eldridge (back, second from left), and Charles Peterson (back, far right).

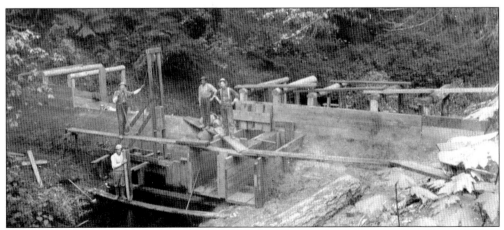

Laborers build the Chimacum Creek Dam for the Western Steel Corporation. Pictured here, businessmen Hooke, Williams, and Somerset contracted the project.

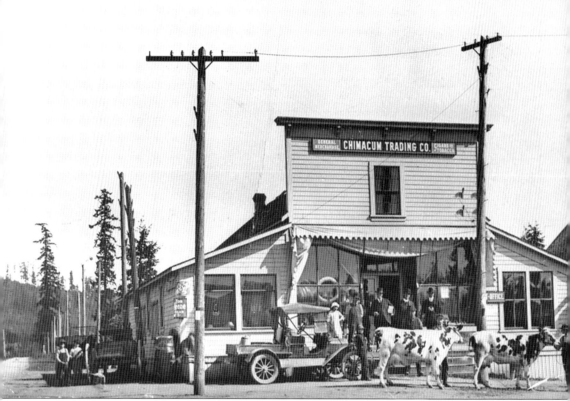

Opened in 1903 by Alfred Van Trojen on the southeast corner of the Chimacum intersection, the Chimacum Trading Company included a general store and community post office. It closed in 1932.

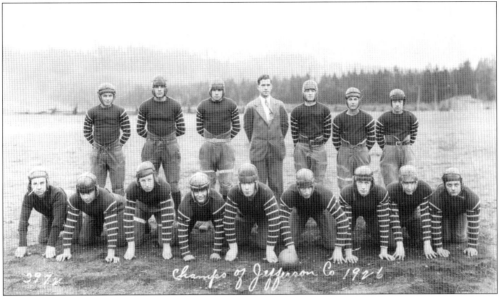

The boys of the Chimacum football team were the "Champs of Jefferson County" in 1926.

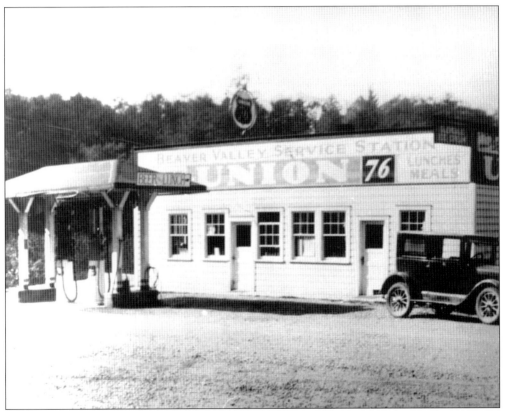

Built in 1931 by Nils Anderson on the corner of Beaver Valley Road and Larson Lake Road, the Beaver Valley Store in Chimacum is pictured here around 1920. In 1950, the store was moved back 50 feet when Beaver Valley Road was widened and paved.

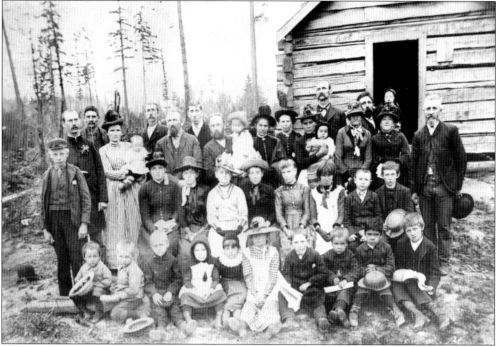

Center residents gather outside their church and schoolhouse in the late 1880s. The building was originally a stoking ranch.

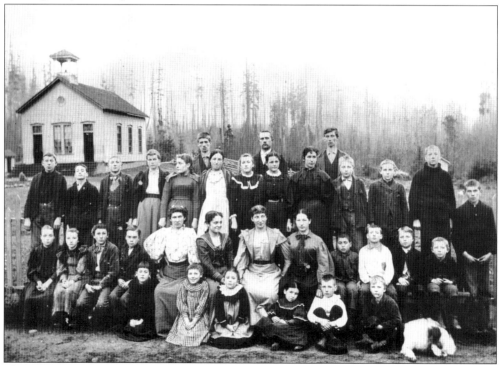

The new schoolhouse in Center, built in a more traditional architectural mode than the previous log cabin, served all grades in the 1890s.

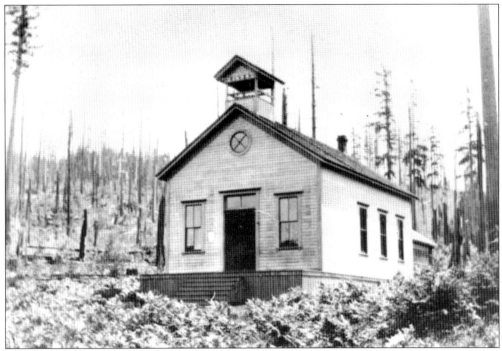

In 1891, residents petitioned for a school district in the Tarboo Valley. The Tarboo School, built in 1894, welcomed 10 students on its first day of classes.

This ramshackle cookhouse served loggers at logging sites in Gardiner.

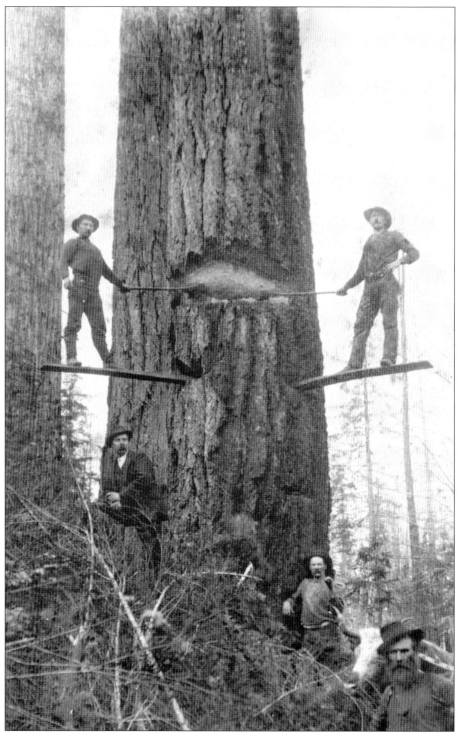

Fallers, loggers in charge of felling trees, risked life and limb in their efforts to down a large fir in a Hadlock forest. The men, working in pairs, would stand on springboards, chopping and sawing until the tree finally fell.

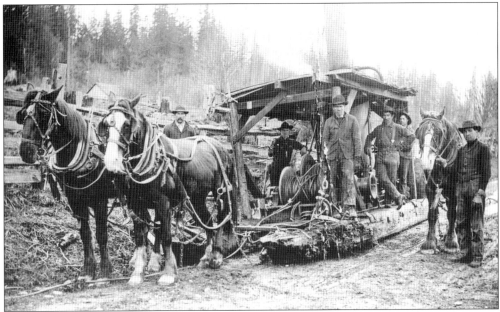

Lumbermen of the Hall and Bishop Logging Company used a horse-drawn "donkey engine" in Gettysburg, Clallam County. The company was founded in 1881 by businessman Robert N. Getty. Hall and Bishop Company built three miles of railroad from the town to the bay.

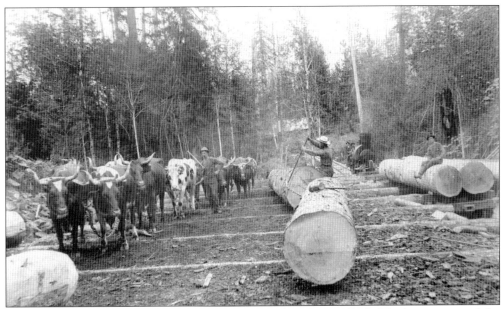

Loggers used a team of oxen to move logs down a skid road in Hadlock. The loggers greased the logs with foul-smelling dogfish liver oil to make the process easier.

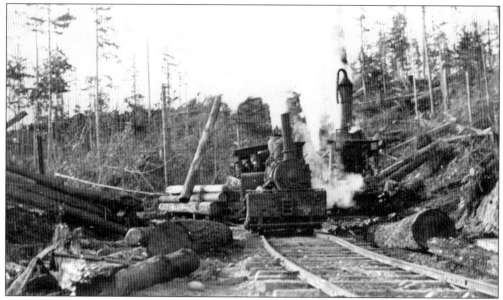

A small shay belonging to the Gardiner Timber and Land Company follows the tracks past a bounty of felled trees in Gardiner, c. 1920. Logging began in Gardiner in 1900.

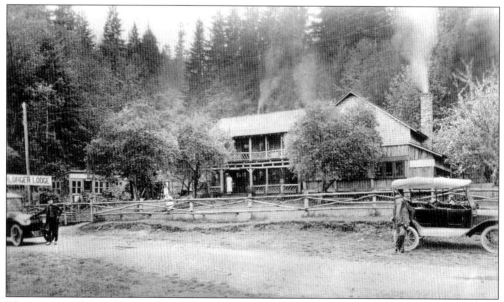

The opening of the Olympic Loop Highway lured tourists to the Olympic Peninsula. The Satterlee family developed a waterfront resort out of the pioneer Linconfelter home. Constructed of native material with a rustic decor, the lodge and cabins could accommodate 125 guests.

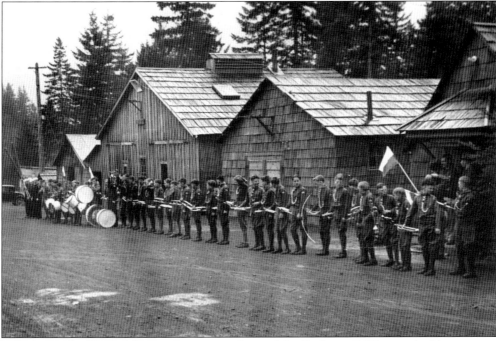

A Boy Scout band is lined up and waiting in front of the Quilcene CCC camp buildings.

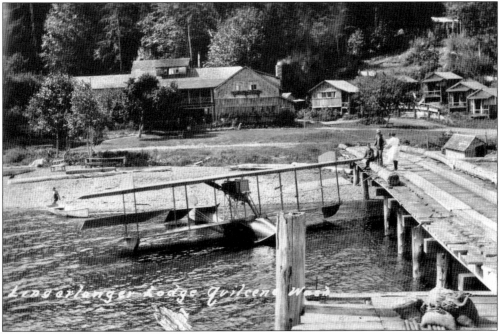

In 1922, Quilcene's Lingerlonger Lodge charged $4 per night, meals included, with even lower rates for those who lingered longer. The Olympic National Park was created in 1938, confirming locals' belief that they lived in one of the most beautiful parts of America. The popular resort was extensively damaged by fire in 1928, rebuilt on a smaller scale, and burned again in the late 1950s.

Quilcene has long been renowned for its oysters. In the 1930s, an oyster hatchery, seeded by Japanese oysters, became a great success. By 1984, Jefferson County had 700 acres of oyster lands.

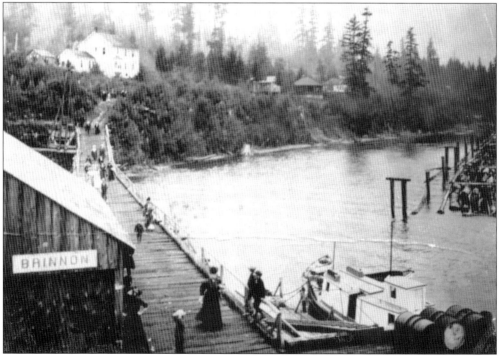

Julius Macomber, a steamboat captain, built the first dock in Brinnon. The dock was conveniently located a half mile from Macomber's Store and Hotel. Macomber became the town's postmaster in 1888.

In Brinnon, Macomber's Store and Hotel sat on the hill, providing its guests with a lovely view of the water. The building was bought by the Izett Logging Company in 1907.

Julius Macomber built a store and post office in Brinnon around 1886. His home was large enough to be used as a hotel. In 1906, the store, dock, and business were sold to the Izett Logging Company. Sometime before 1918, the Macomber store burned. The store pictured here was built in 1918 by Thomas Miller. T. B. Balch purchased it in 1921 and operated it for 24 years. C. V. Dorothy then purchased the store from T. B. Balch in 1945. The store burned, so Dorothy built a new store on the present site.

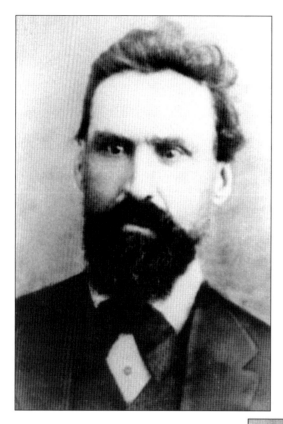

In the 1860s, Elwell P. Brinnon and his S'Klallam wife, Kate, homesteaded at the mouth of the Duckabush River. Soon after, they considered even the few homesteaders on the Duckabush to be too many and relocated to the Dosewallips River area. By the 1880s, the Brinnons owned most of the property in the lower Dosewallips Valley and gave much to the community that now bears their name. This photograph was taken on December 29, 1885.

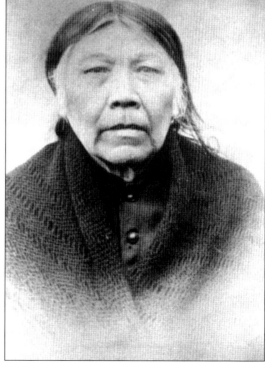

Kate Brinnon, the wife of Ewell Brinnon, was born O'Wota, the daughter of Lach-ka-nim, a prominent member of the S'Klallam tribe. Kate's (O'Wota) brother was Chits-a mah-han, chief of the S'Klallam tribe, also known as Chetzemoka or The Duke of York.

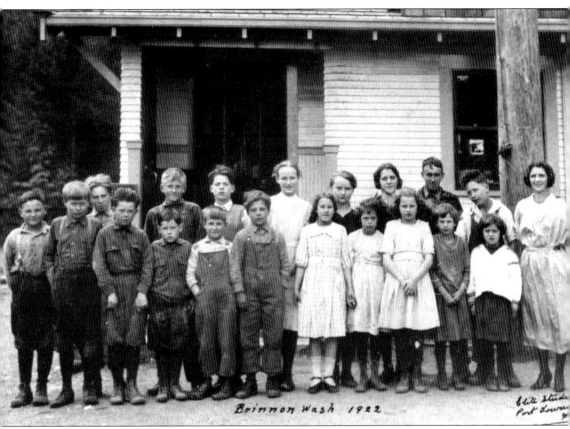

Brinnon Wash 1922

Pictured here is the Brinnon class of 1922. From left to right, they are (first row) Norris West, Eivind Hjelvick, Bob Clements, Dick Clements, Sherman Allison, Charles Jameson, Erma Erickson, Marie Bunnell, and three unidentified girls; and (second row) Herb Brown, Robert Swanson, John Clements, Flora Allison, Wilma Jameson, Constance Clements, Harvey Boyce, Jim Allison, and teacher Margaret Foy.

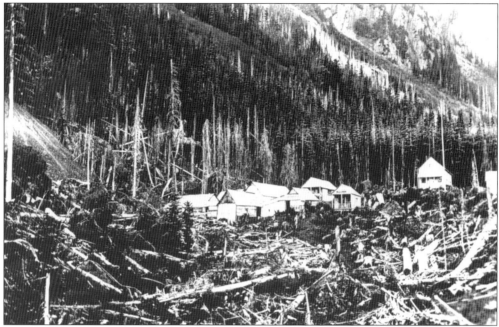

The claim holders of the Tubal Cain Mine, located about 24 miles from Quilcene, hoped to find copper, manganese, and iron, among other things. The facility, largely erected in 1904, featured a cookhouse, an office building, a machine shop, a blacksmith shed, a clubhouse, and a bunkhouse with room for 35 men.

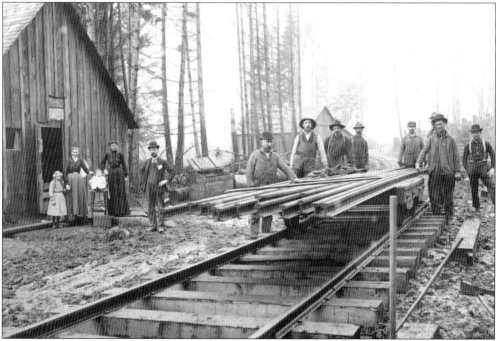

A crew at the Tubal Cain Mine is ready to construct a rail system for carts in the mine shaft. The mine never produced hoped-for riches despite nearby optimistically named Silver Lake and Copper Creek.

Seven

THE WILDS AND
THE WEST

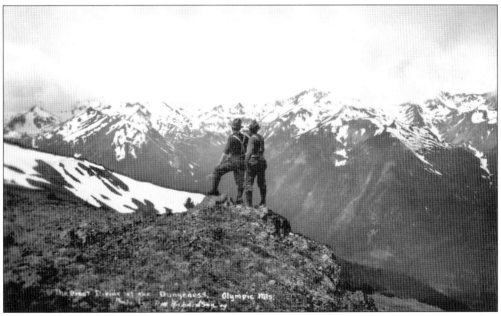

Not until 1890 was there a serious effort to settle in the Olympic Mountains and the rainforest of the Hoh River watershed. Homesteading in western Jefferson County was generally a temporary affair. Upland settlers rarely stayed for more than a few years before selling their property to timber companies and moving to the more fertile valleys. When President Cleveland's 1898 Forest Reserve Act put over two million acres of peninsula timberland in the hands of the federal government, this further convinced homesteaders to pull up stakes and head for lower, dryer land. This pattern continues today, with the population centered in the valleys and the mountainous regions left largely to timber companies and the state and federal governments. Here hikers brave the Dungeness River Valley High divide.

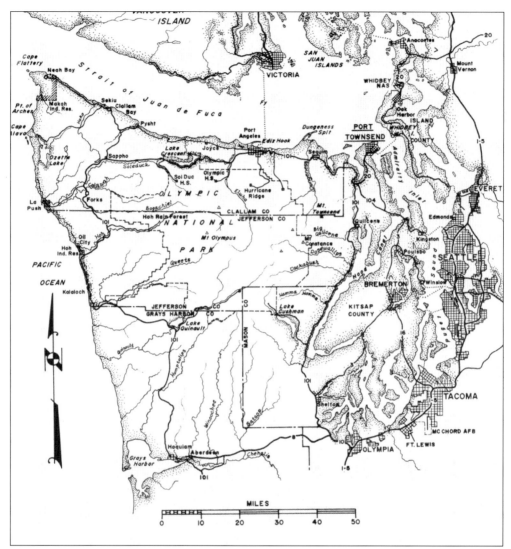

The Olympic Peninsula is a large arm of land in western Washington State between the Pacific Ocean and Puget Sound. It is the westernmost point in the contiguous United States and is dominated by the Olympic Mountains, Olympic National Park, and the Hoh and Quinault rain forests.

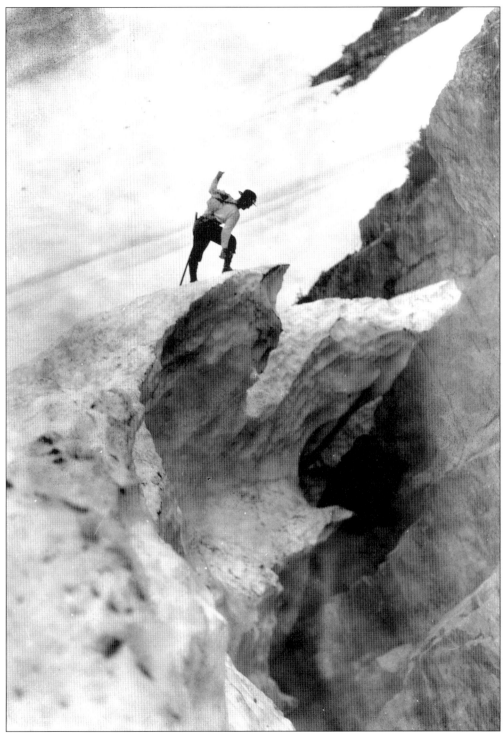

A backpacker peers into the abyss of a crevasse on Mount Constance.

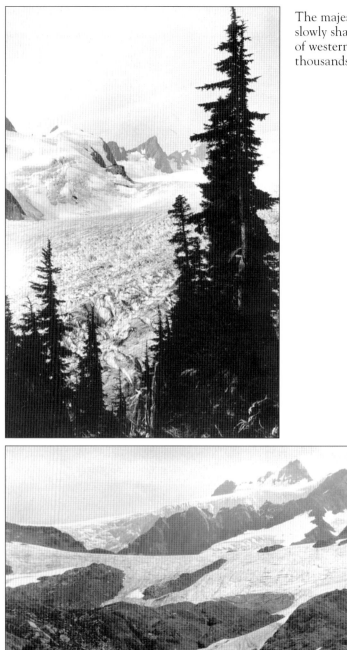

The majestic Hoh Glacier has slowly shaped the rocky landscape of western Jefferson County for thousands of years.

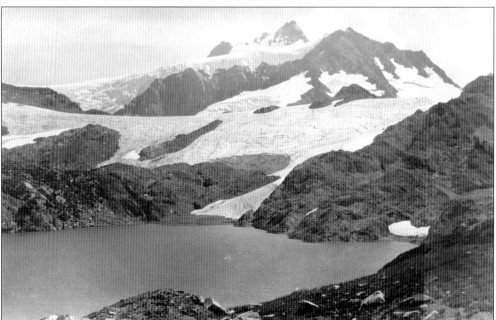

The tranquil lake at the top of Mount Olympus looks much the same today as it did in 1924.

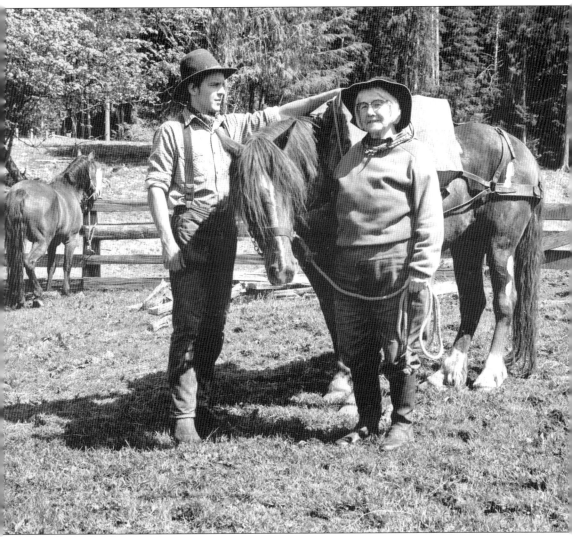

Minnie Peterson, born near Sekiu in 1891, was a backpacker and guide in the Olympic Mountains. She is pictured here with a friend and trusted pony.

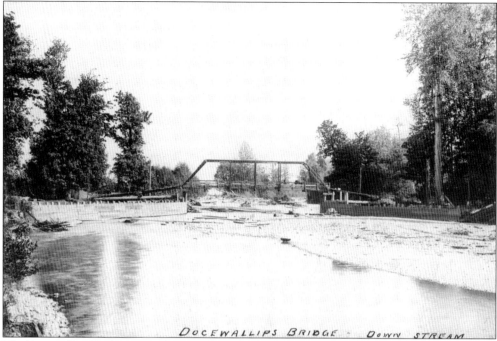

The Dosewallips Bridge is seen here from downstream.

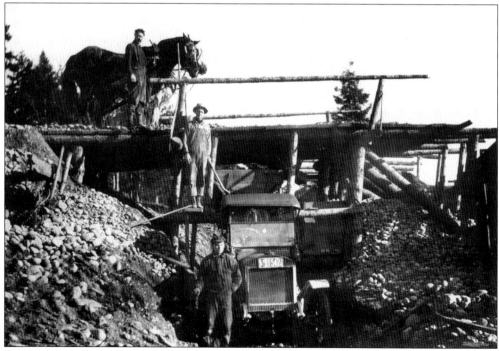

Quarry men bring civilization to the wilderness at a rock quarry in western Jefferson County.

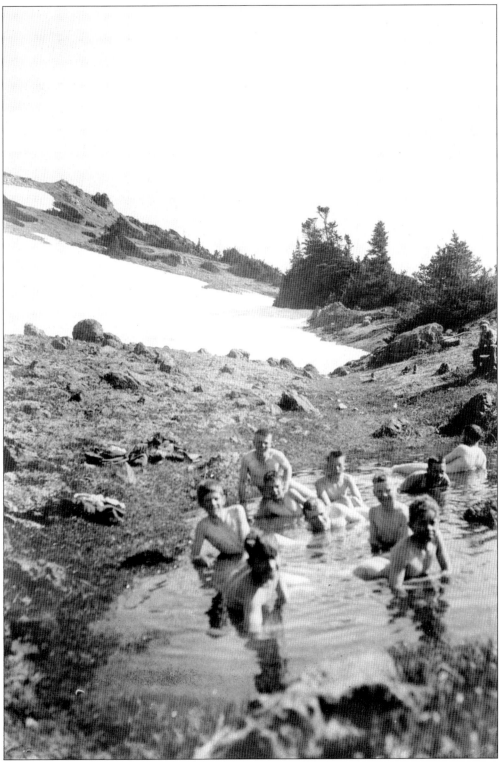

Boy Scouts skinny-dip in a glacial pool in 1941.

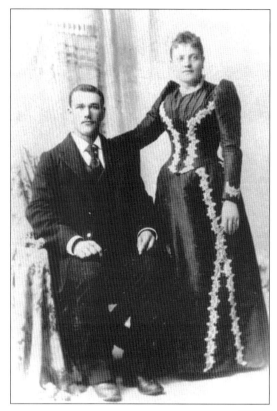

After staking out his homestead in western Jefferson County, John Huelsdonk returned to Iowa and married his foster sister, Dora Carolina Wilhemina Wolf. This wedding photograph shows them shortly before their westward journey. Soon the entire Huelsdonk family came to the Hoh.

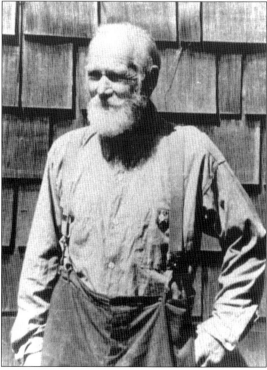

In his prime, John Huelsdonk weighed over 225 pounds and stood tall at 5 feet, 10 inches. He was enormously strong. The most notable legend alleges that while packing supplies into the logging camps, he was asked to carry in a stove (that was, in fact, bulky but comparatively light) and stuff the stove with groceries, including a 50-pound sack of floor. When asked about the huge load, Huelsdonk replied, "It was the shifting sack of flour in the stove that was causing the difficulty." The story grew until the load was 200 pounds or more and fed Huelsdonk's legendary reputation as the "Iron Man of the Hoh."

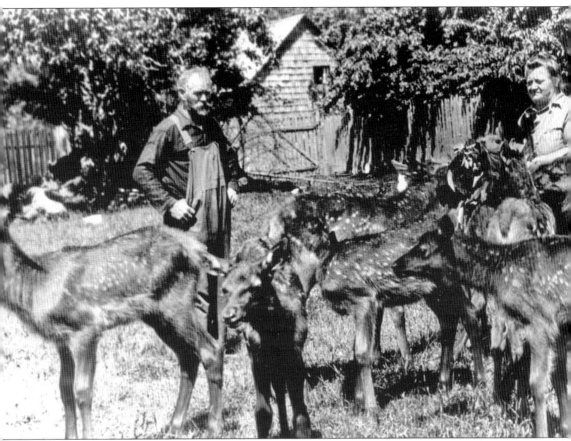

John and Dora Huelsdonk tend to young elk on their property. As the elk populations grew beyond their previous numbers, Huelsdonk caught and raised elk calves for zoos, game exchanges, and to repopulate areas where they had become extinct.

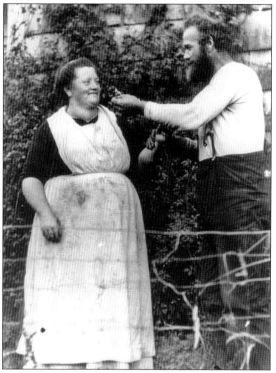

John and Dora Huelsdonk, pictured here engaged in a playful exchange in 1911, established a 160-acre homestead on the Hoh River in western Jefferson County in the fall of 1892. They raised four daughters on the Hoh, and Huelsdonk earned legendary status in the area for his physical strength and ruggedness.

Lena Huelsdonk, the eldest daughter of John "The Iron Man of the Hoh" Huelsdonk, became something of a legend in her own right. She attended the University of Washington where she majored in home economics and became a teacher before marrying Fred Fletcher, with whom she raised six children. She served as justice of the peace in western Jefferson County for 40 years and upheld her reputation as a rugged pioneer and an outspoken critic of Washington state politics until her death. She is pictured here in 1918 at the time of her marriage to Fletcher.

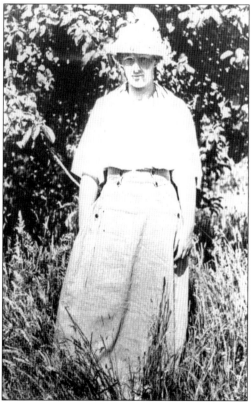

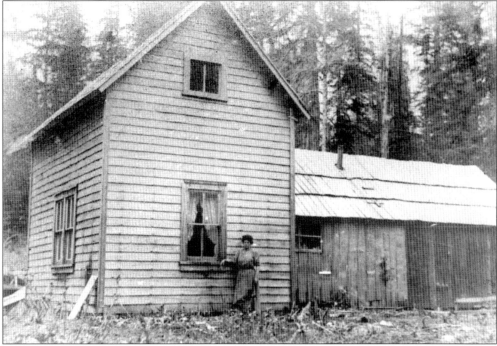

The Horners, like the Huelsdonks, attempted to carve out a rugged existence in the lower Hoh area. Many early settlers of the Hoh sold their land to timber companies at the first opportunity, unable to withstand the hardships.

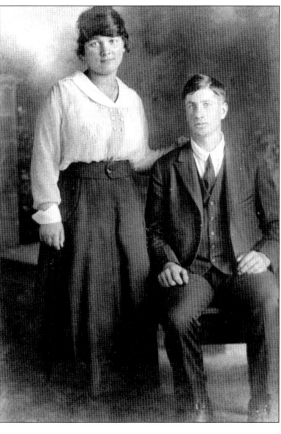

John R. and Elizabeth Fletcher, siblings of Fred and Lena Fletcher respectively, lived on the homestead of Elizabeth's father, John, and owned the homestead of Elizabeth's grandfather, Herman Huelsdonk.

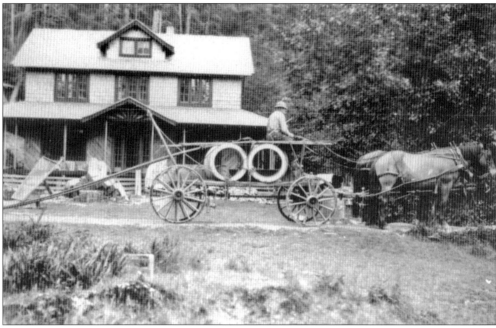

Hoh homesteader Isaac Anderson's horse-drawn wagon idles before the Fletcher home. Cooperation between neighbors was vital to the success of a wilderness homestead.

The Hoh School, located on the lower Hoh River, was outrageously remote. To reach the school from any semblance of civilization, one had to hike a six-mile trail or cross the Hoh River by canoe (though a road must have been established at some point, considering the car at the edge of this 1938 photograph). In its later days, the school's only students were members of the Cassell family, and when the last Cassell child was sent to Forks in 1941, the school closed.

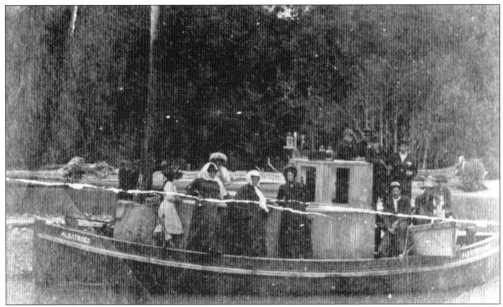

The *Albatross*, owned by Ernest Anderson, ferried people and freight down the Hoh River. The craft also made trips up the Queets and Quillayute Rivers.

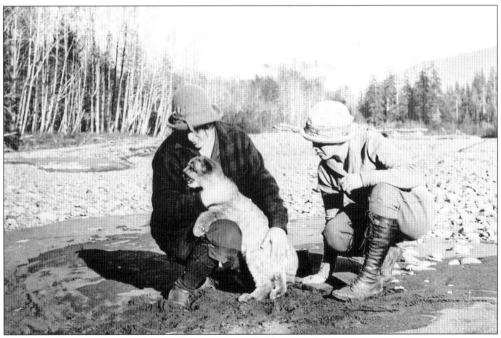

Maril Huelsdonk and Agnes Rotching are pictured here with a young cougar.

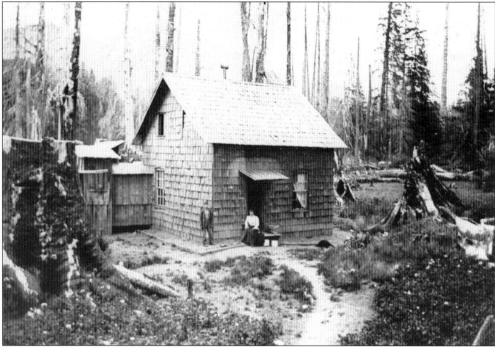

This is Herman Huelsdonk's homestead. Nineteenth-century homesteaders in the interior lived mainly on vegetables and bread and occasionally venison and fish. Clearing underbrush and larger trees was their primary and ongoing objective.

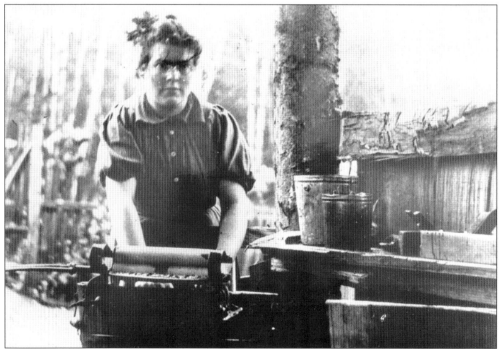

Myrtle Fletcher is washing clothes at the family home of Henry Fletcher, her father. She is about 15 years old here.

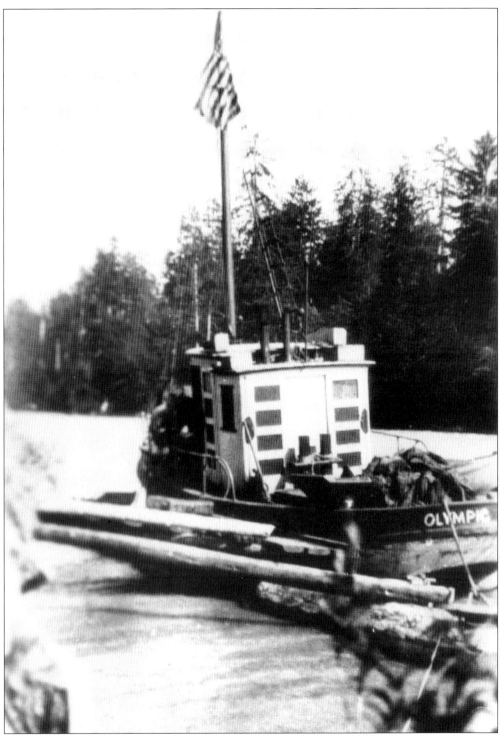

The *Olympic* rests at a landing on the Lower Hoh River. The craft was used to troll the tortuous river for spruce in the early 1920s.

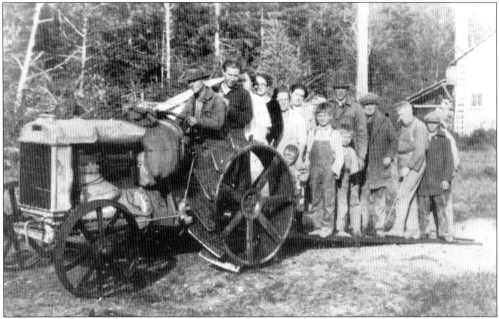

A celebratory crew of farmers greets the first tractor to work the soil of the Hoh Valley. Pioneer George Fletcher used the tractor to work his farm.

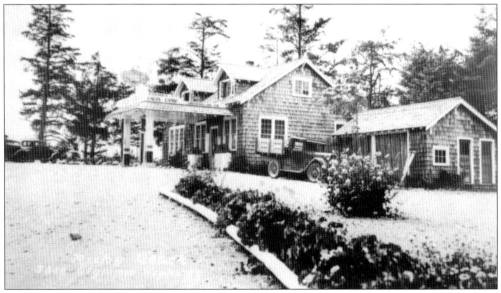

In 1925, John and Elizabeth Fletcher bought property on the coast south of the Hoh River. They worked on it for three years and developed the Ruby Beach Resort, composed of a store, small restaurant, gas pumps, 13 cabins, and a lodge. John's paneling and hand-split wood graced the decor. Elizabeth's wonderful cooking and the wild beauty of the coast made Ruby Beach a popular spot among locals and tourists. During World War II, the U.S. government told the Fletchers they had to move out. The government paid the Fletchers for the property and loaned them the trucks to move. John and Elizabeth tried to take the government to court, but they were not powerful or rich enough. John's handiwork was eventually torn down or burned, and a livelihood they had worked towards was abruptly put to an end.

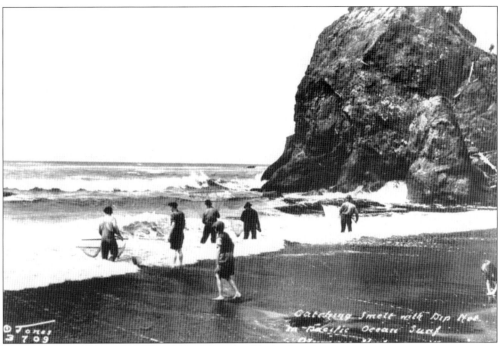

Pictured here are commercial smelt fishermen at Ruby Beach.

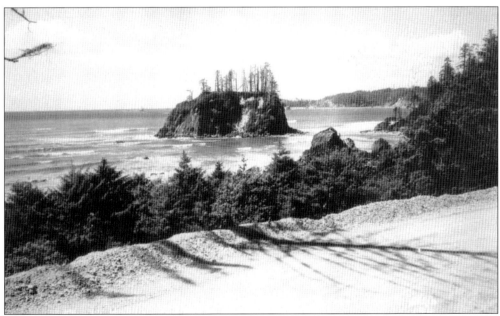

Abbey Island is a rock island, including a large cave, located three miles south of the mouth of the Hoh River directly west of Ruby Beach. It has been heavily eroded by wave action. In 1866, it was named by the U.S. Coast Guard survey because of a fancied resemblance to an ancient abbey.

ACROSS AMERICA, PEOPLE ARE DISCOVERING SOMETHING WONDERFUL. *THEIR HERITAGE.*

Arcadia Publishing is the leading local history publisher in the United States. With more than 3,000 titles in print and hundreds of new titles released every year, Arcadia has extensive specialized experience chronicling the history of communities and celebrating America's hidden stories, bringing to life the people, places, and events from the past. To discover the history of other communities across the nation, please visit:

www.arcadiapublishing.com

Customized search tools allow you to find regional history books about the town where you grew up, the cities where your friends and family live, the town where your parents met, or even that retirement spot you've been dreaming about.